Flower Mandalas Coloring Book

Adult Coloring Book Of Calming & Relaxing Patterns

Stress Relieving Patterns Series Vol. 1

Kim Mills

Copyright © 2017 Kim Mills All Rights Reserved. No part of this publication may be reproduced, distributed or transmitted in any form or by any means, without prior written permission.

You may photocopy the images for personal use to color multiple times or give as gifts. Colored images may be shared online as finished projects with credit given to the book title/author.

First Edition 2017

Kim Mills
Homestead Acres
www.homestead-acres.com

ISBN-13: 978-1546315872

ISBN-10: 154631587X

Tips For Using This Book

Thank you for purchasing my coloring book! I've included some tips below to help you get the most out of your new coloring book.

2 Copies Of Each Coloring Page

This book contains 20 unique images, I've included 2 copies of each image for a total of 40 coloring pages. The second copy is perfect if you would like to color with a friend, fix a mistake or try your favorite pattern in a new color combination.

Single Sided Pages

As a colorist, myself I understand how frustrating it can be when images are printed on both sides of the page. If you want to frame an image it means the loss of the image on the back of the page. Double sided pages also pose a problem for bleed through when coloring. To prevent these problems, I've printed each picture on only one side of the page. No more worrying about sacrificing your art!

Coloring Mediums

The paper in this coloring book is intended for use with crayons and pencil crayons. If you would like to work with wetter mediums such as markers please add a sheet of card stock or a few sheets of paper behind the page you're working on. For the best results remove the page from the coloring book before using wet mediums.

Relax and Enjoy!

Coloring is a stress-reliving activity to enjoy it to the fullest reduce background noise and any distractions while coloring. Allow yourself some quiet time to focus on your art and you will be surprised at how relaxed it can help you to feel. Don't worry about comparing your coloring to anyone else's, your art is original to you.

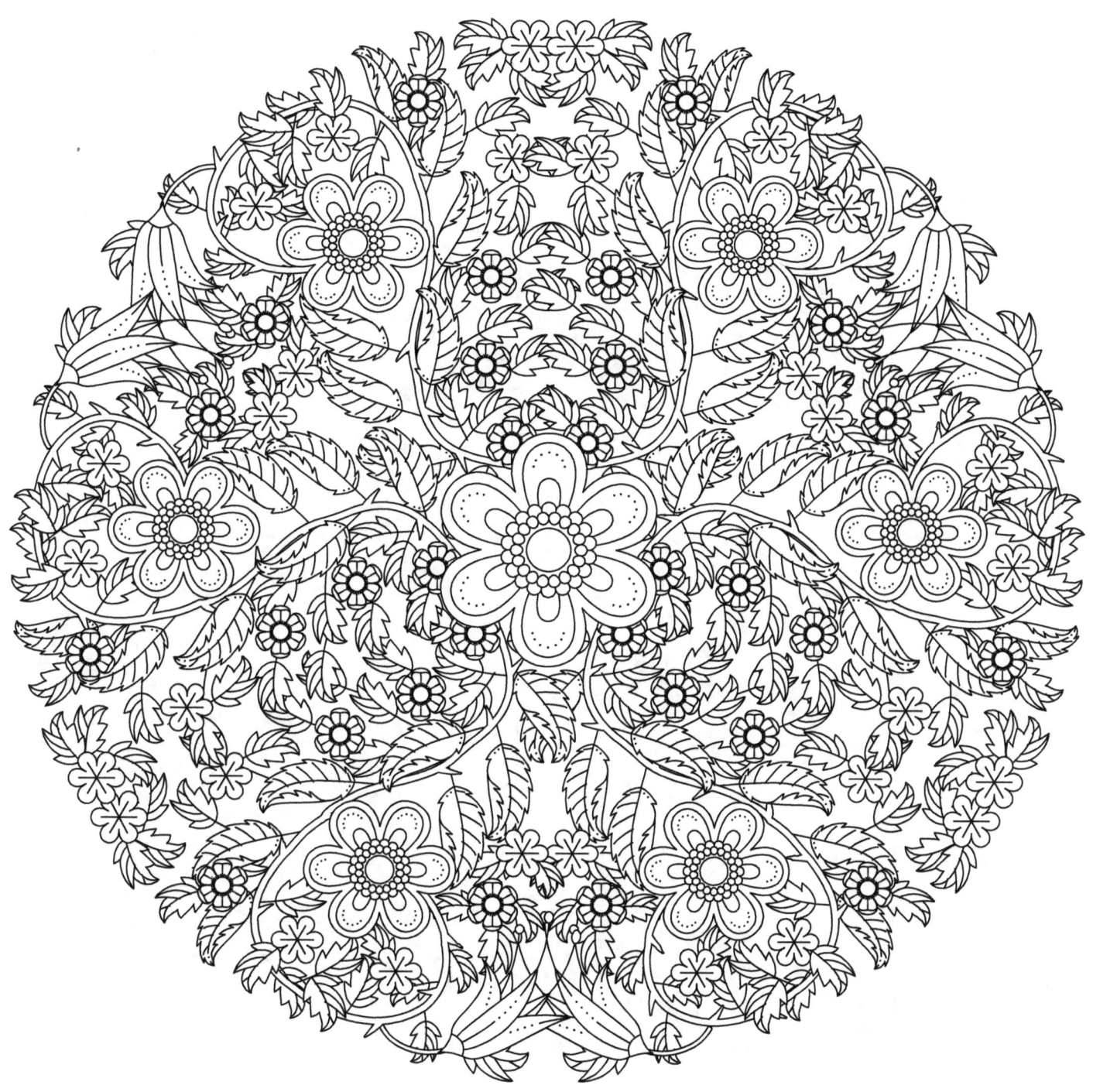

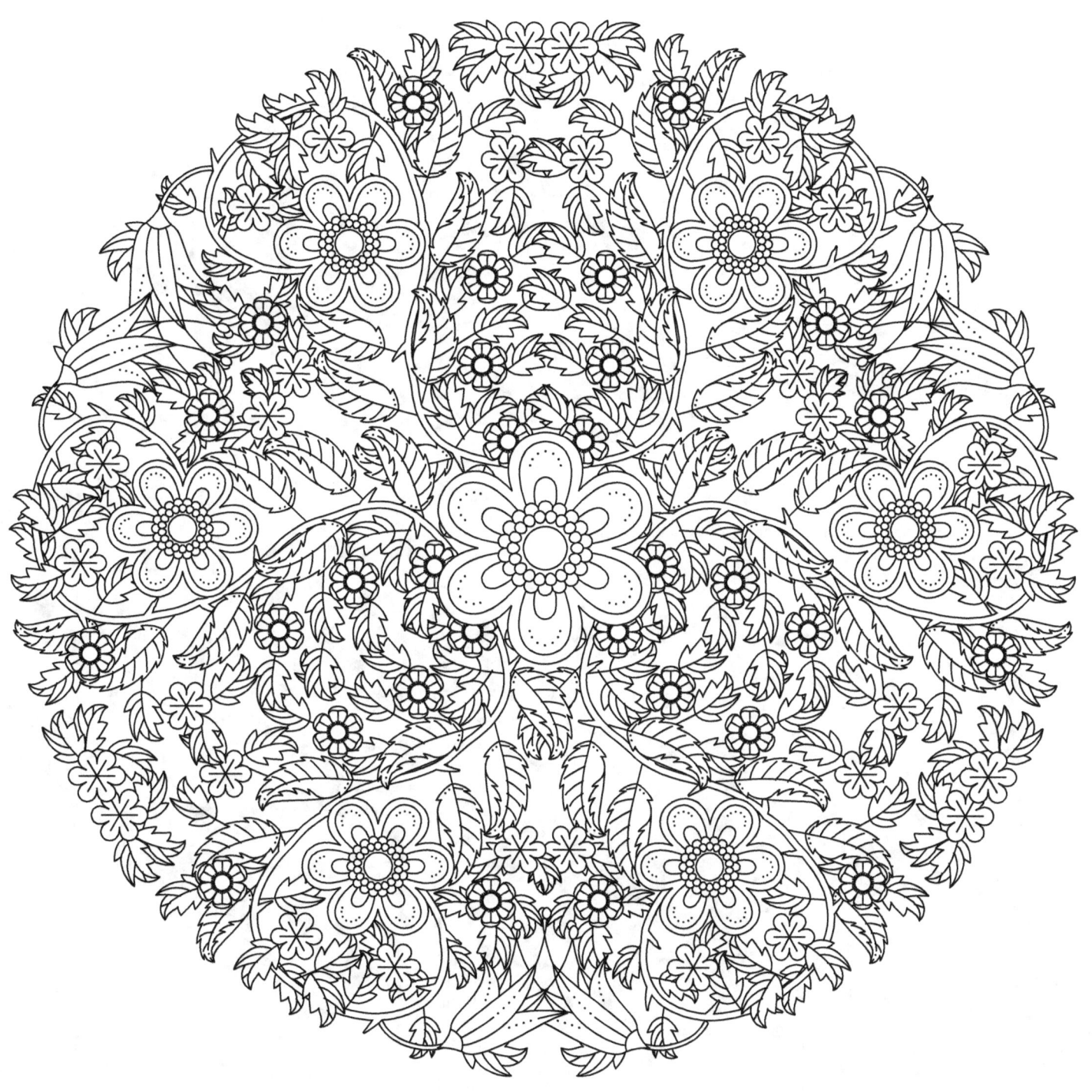

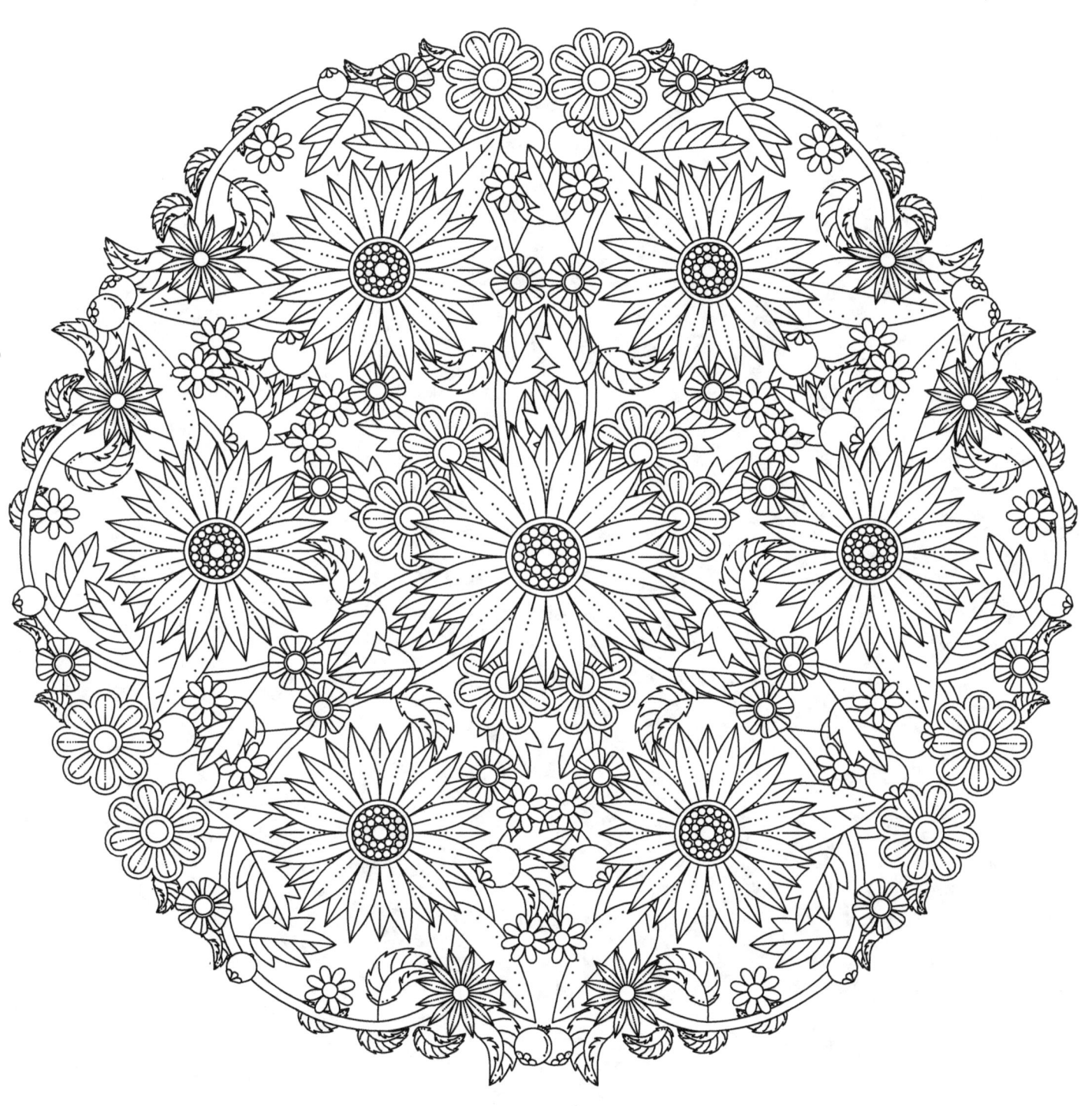

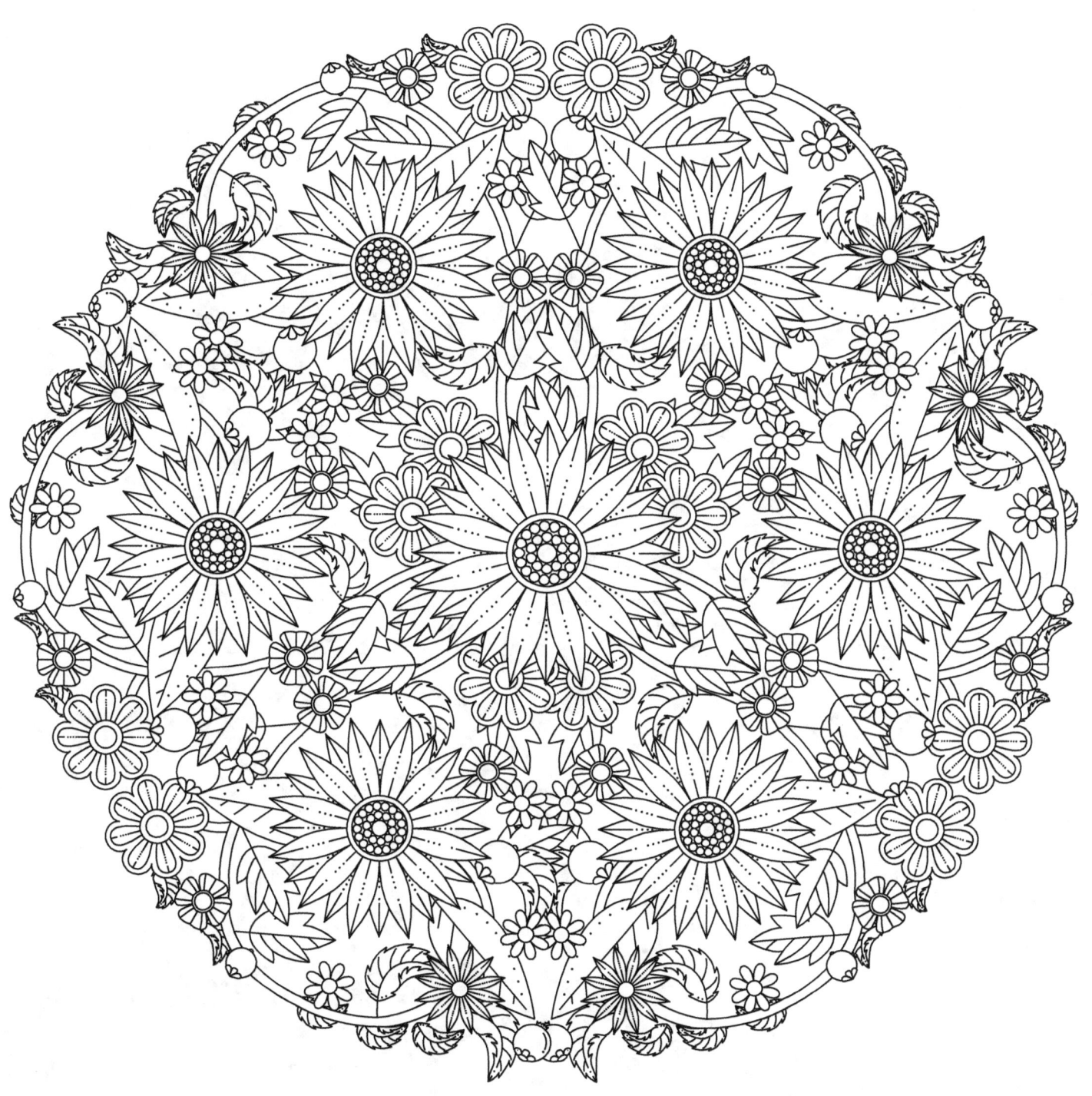

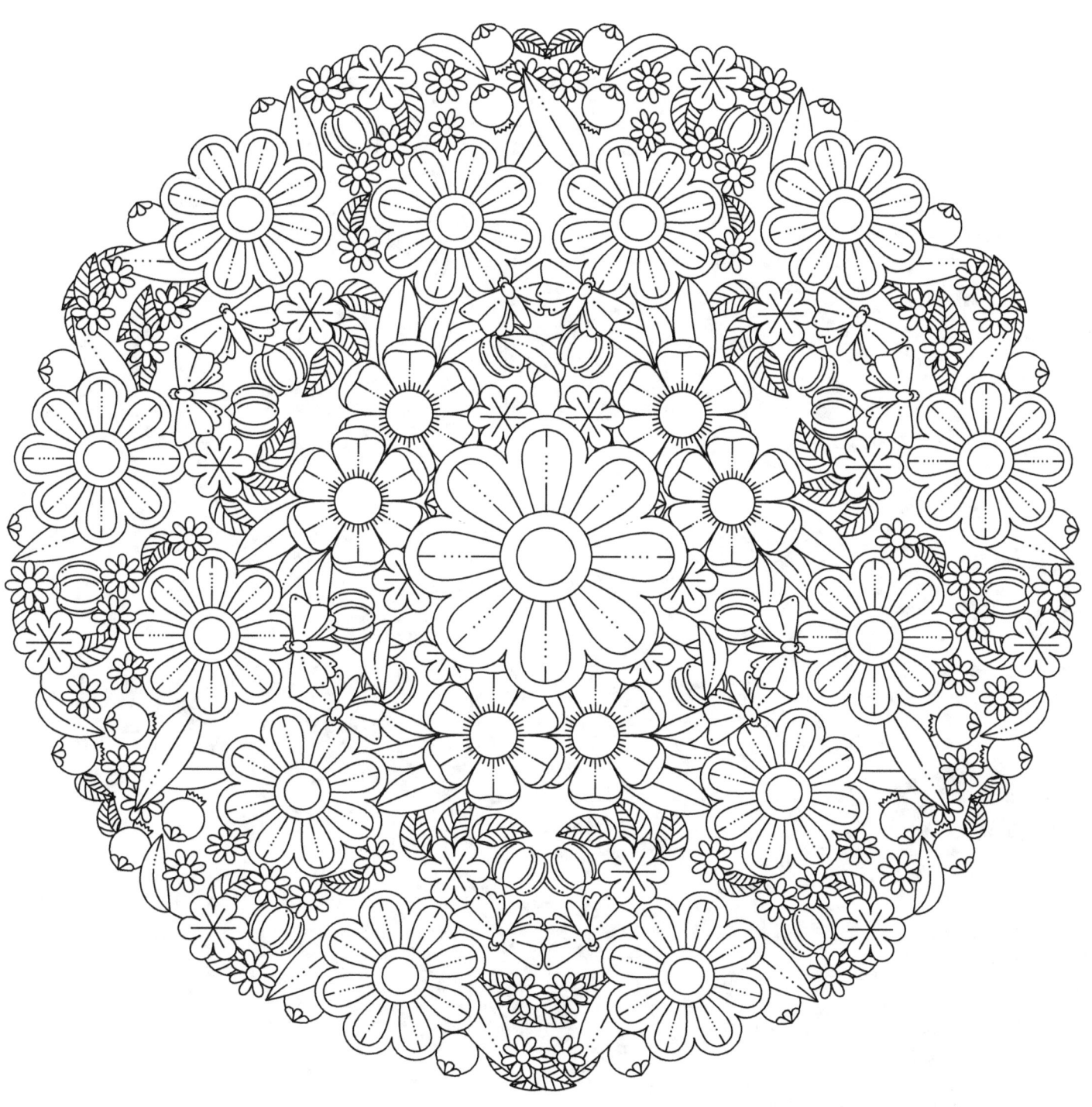

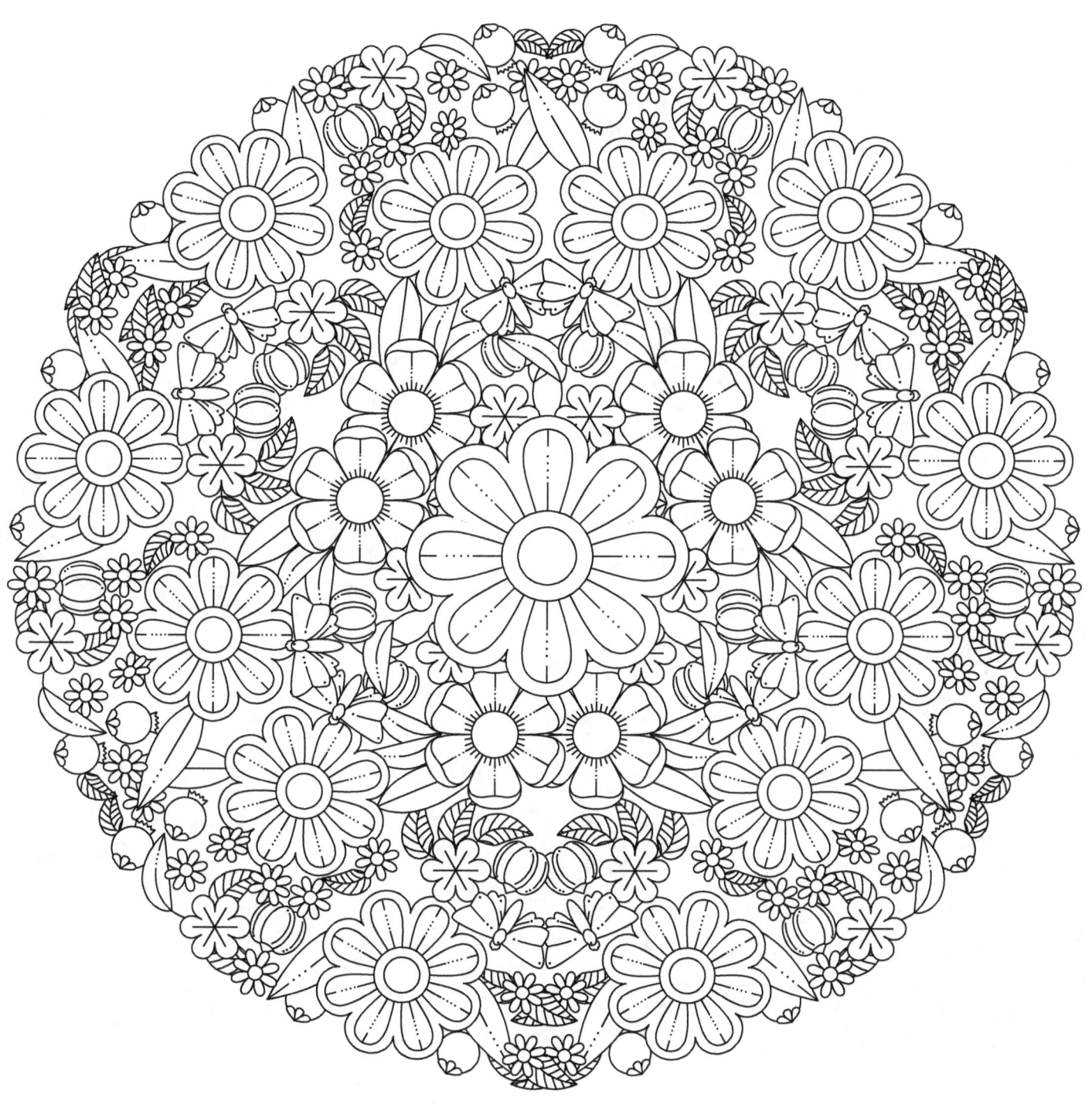

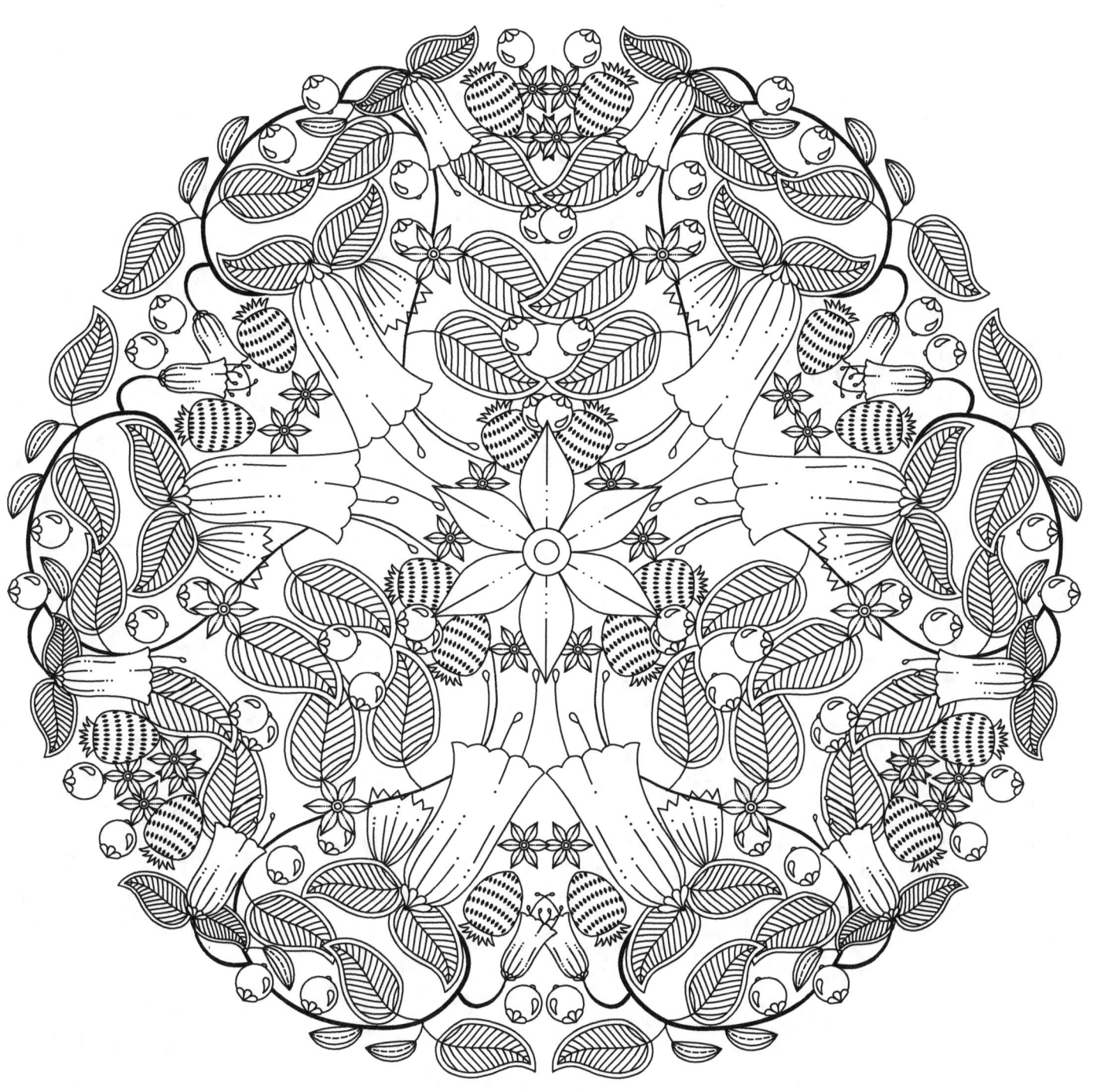

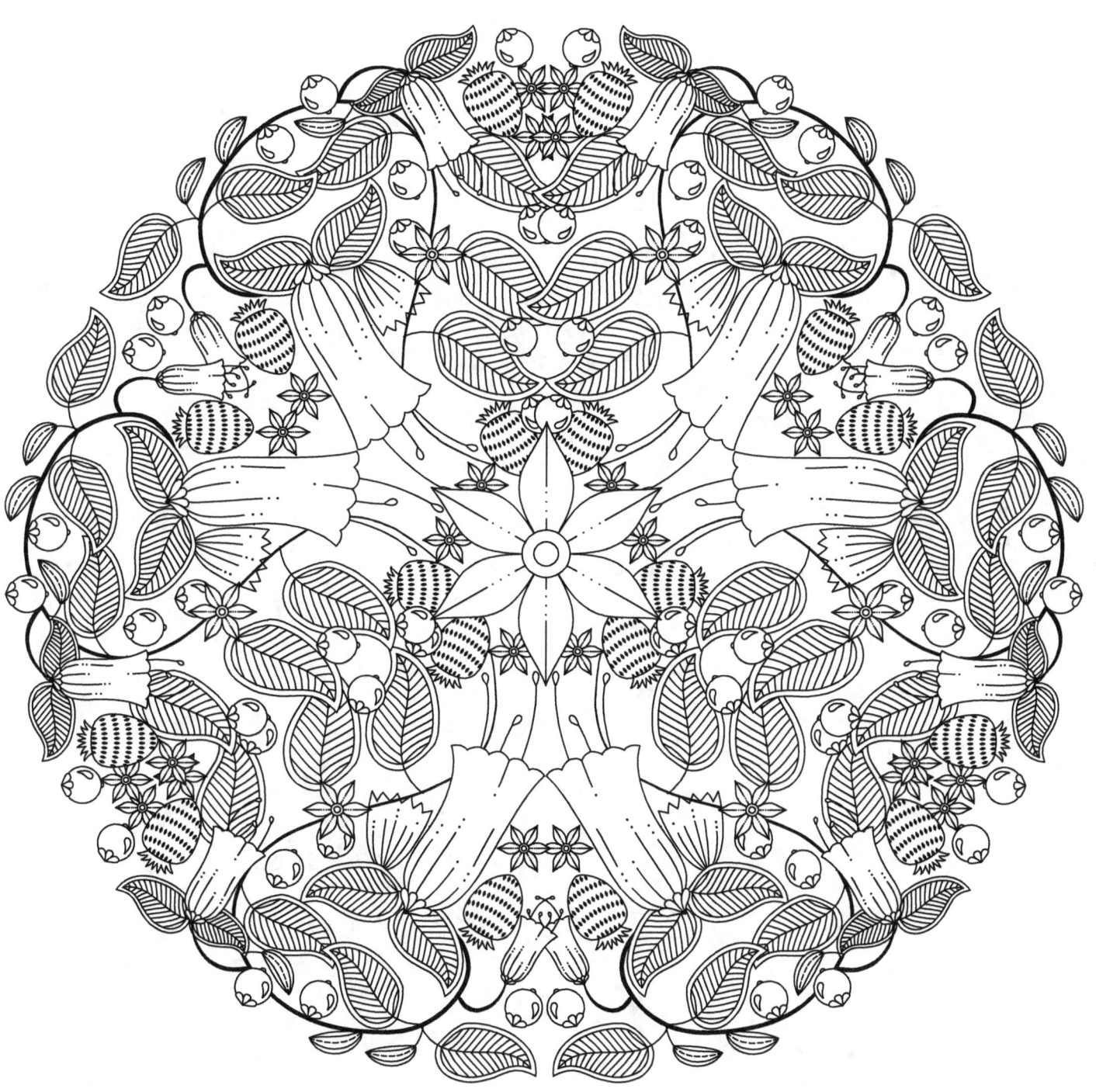

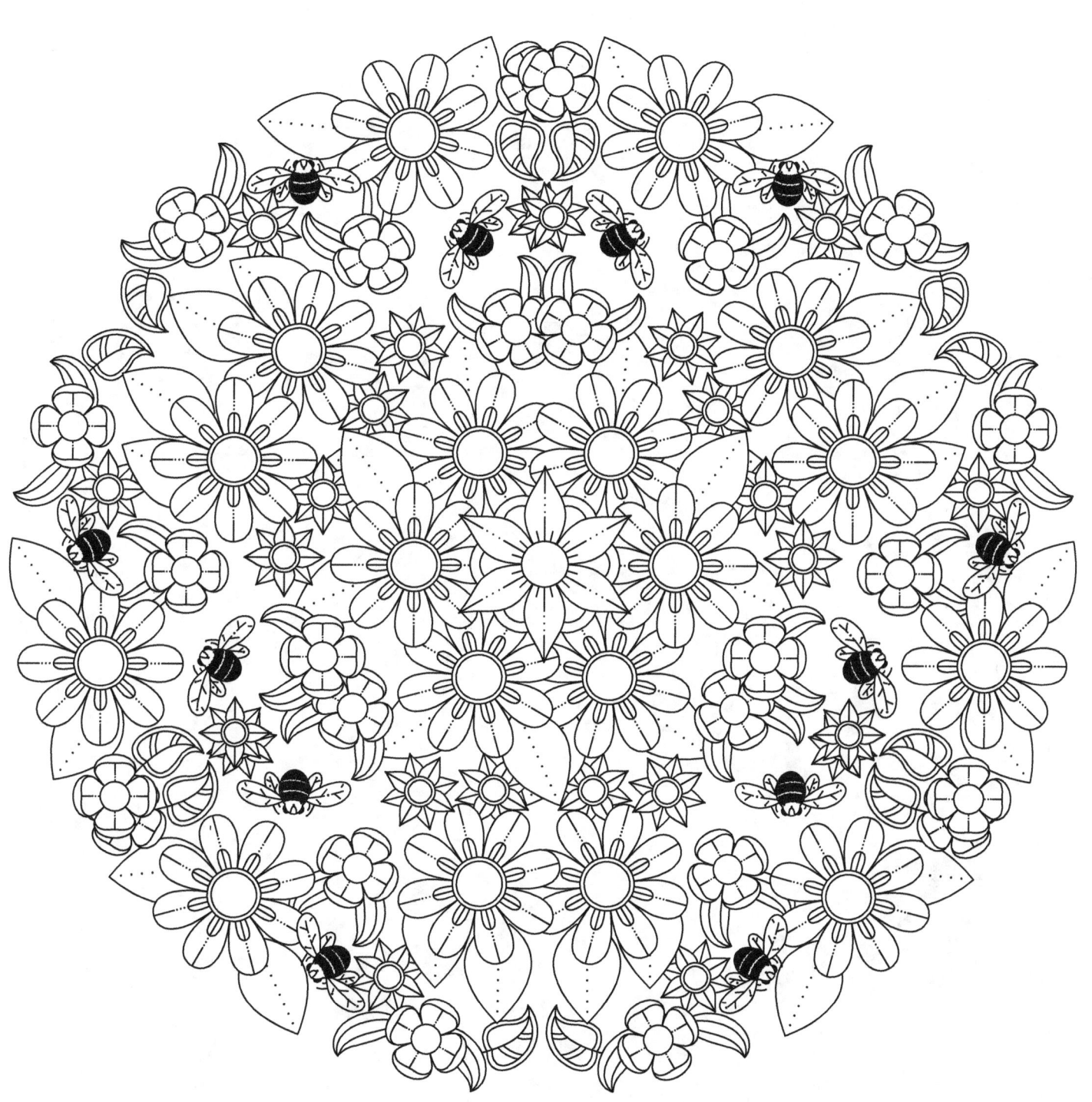

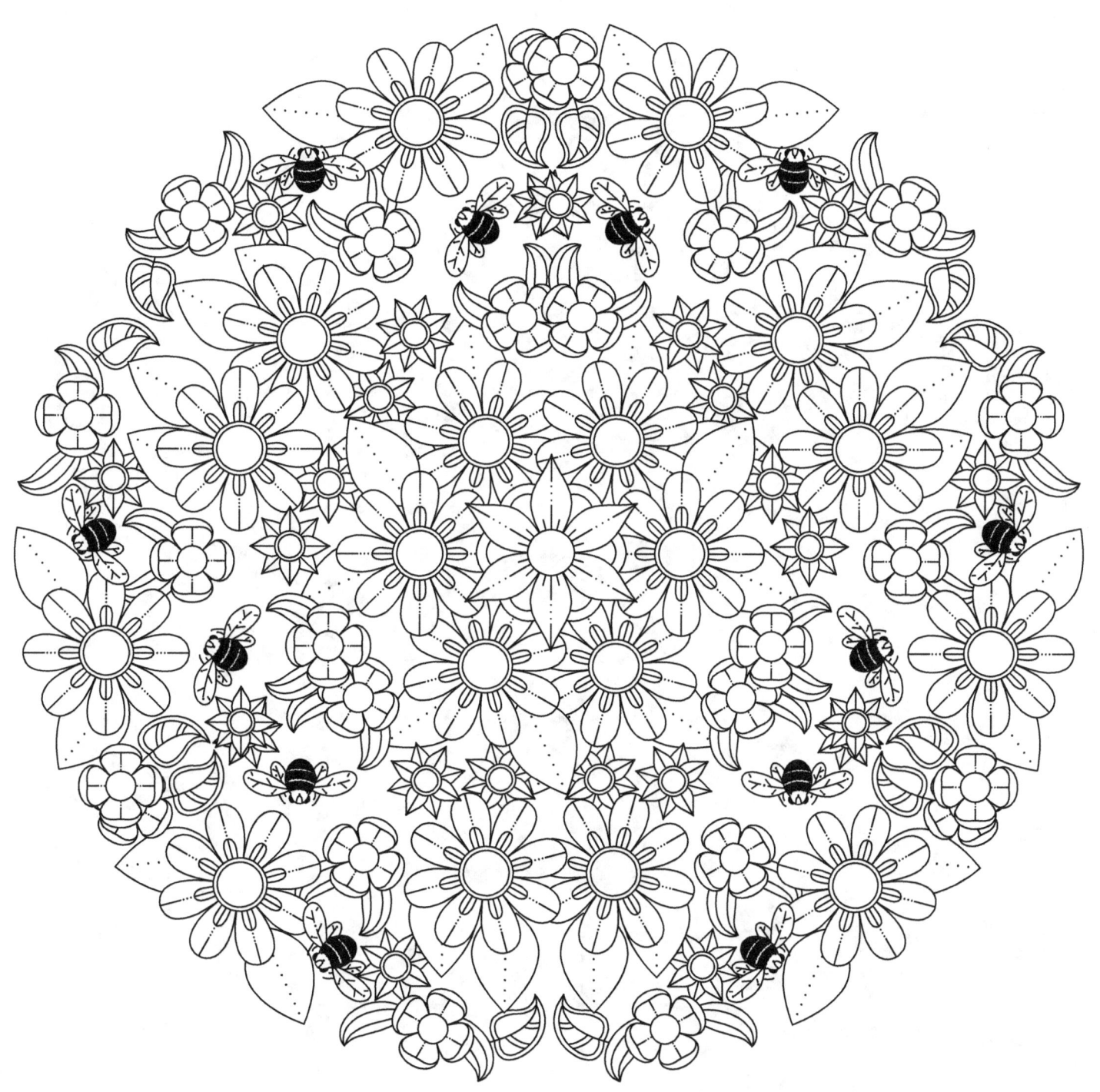

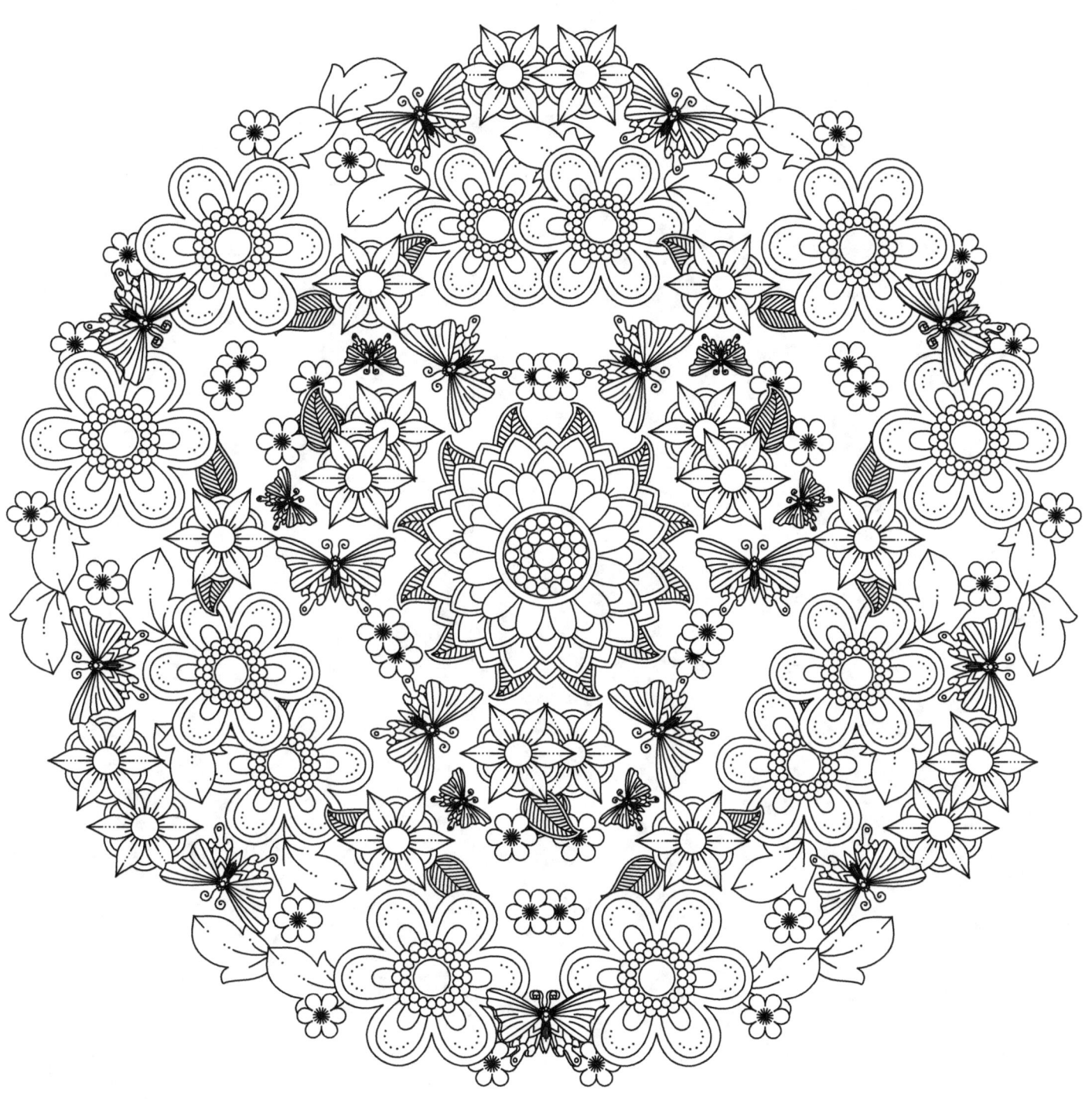

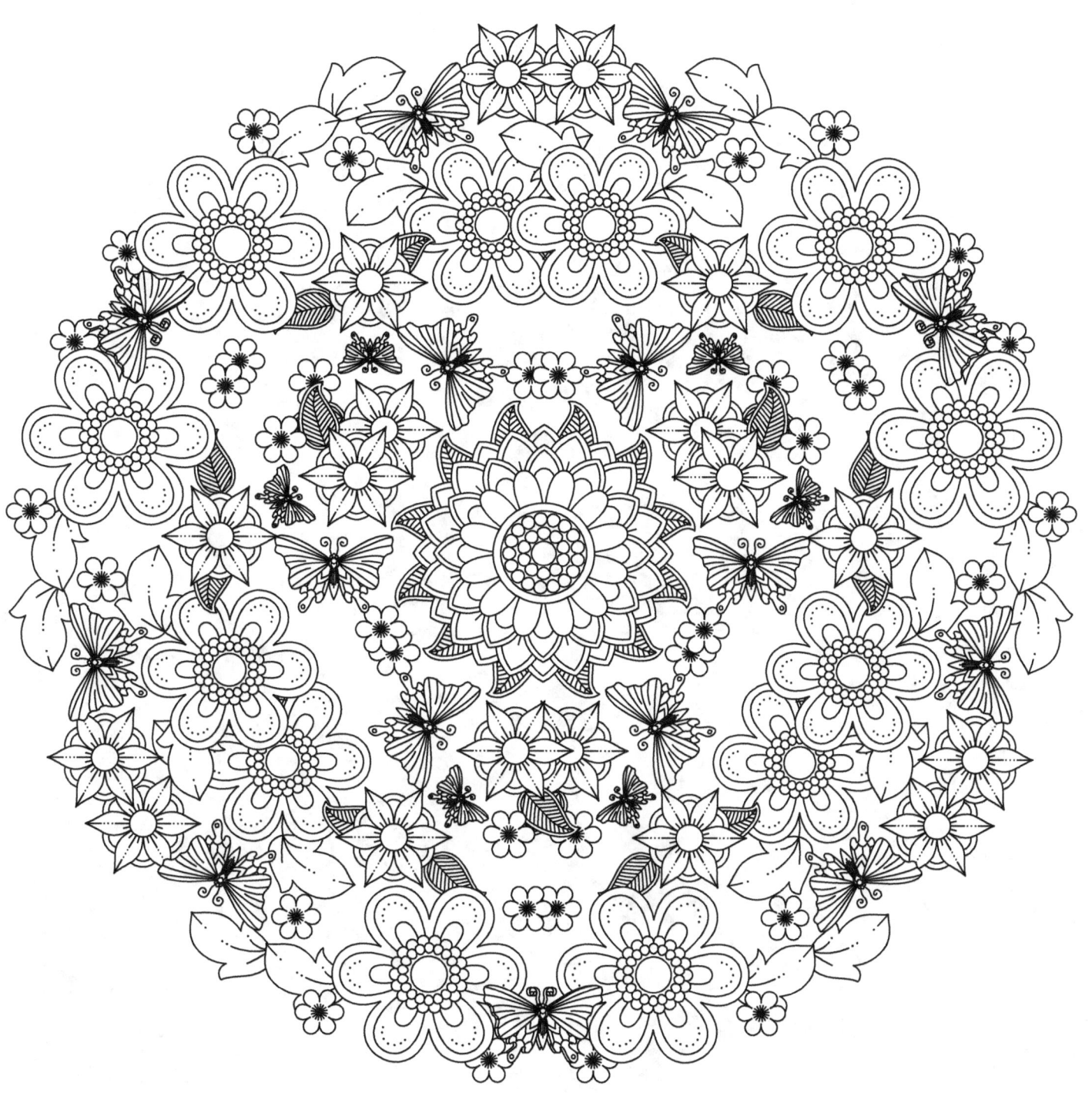

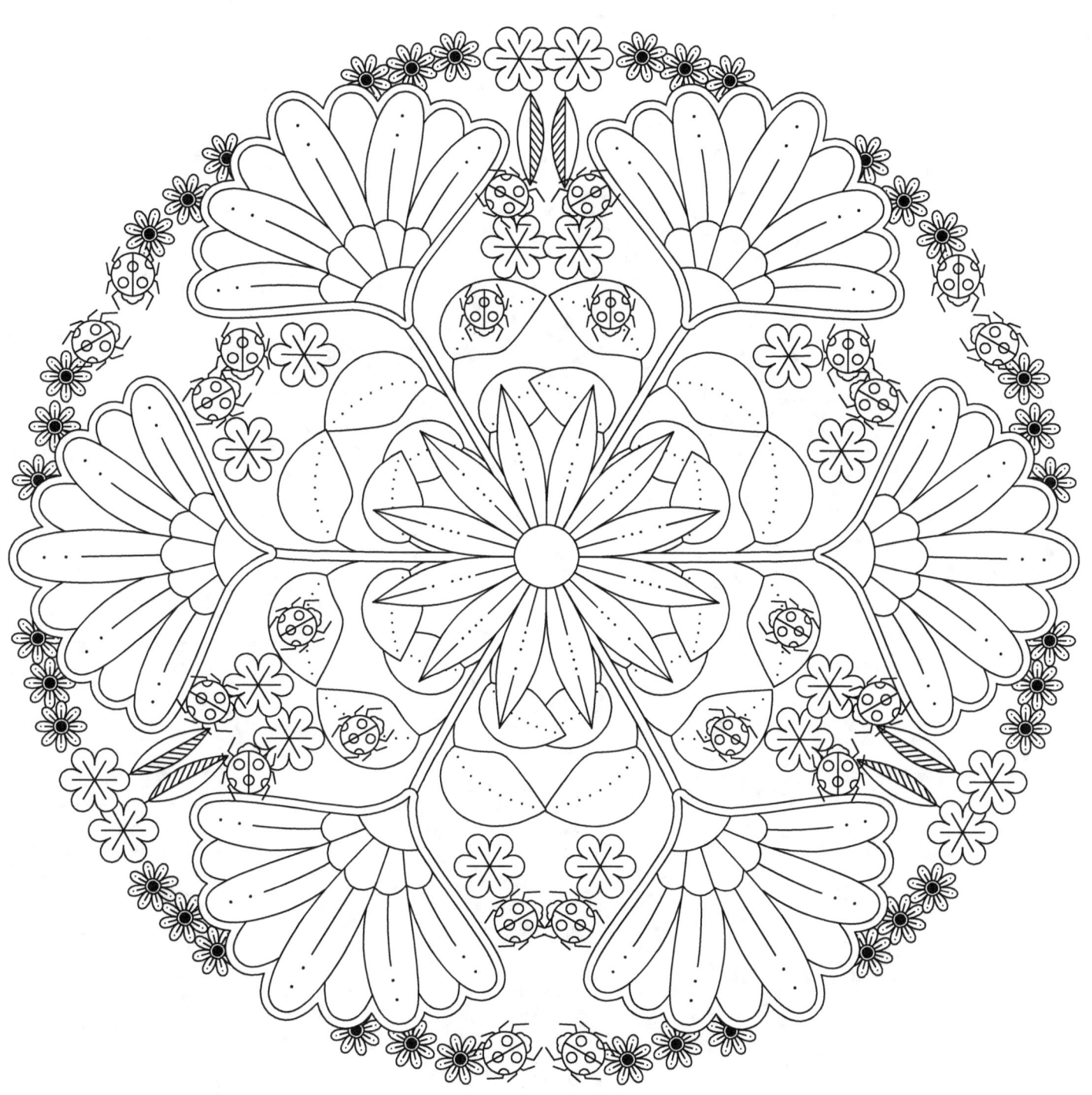

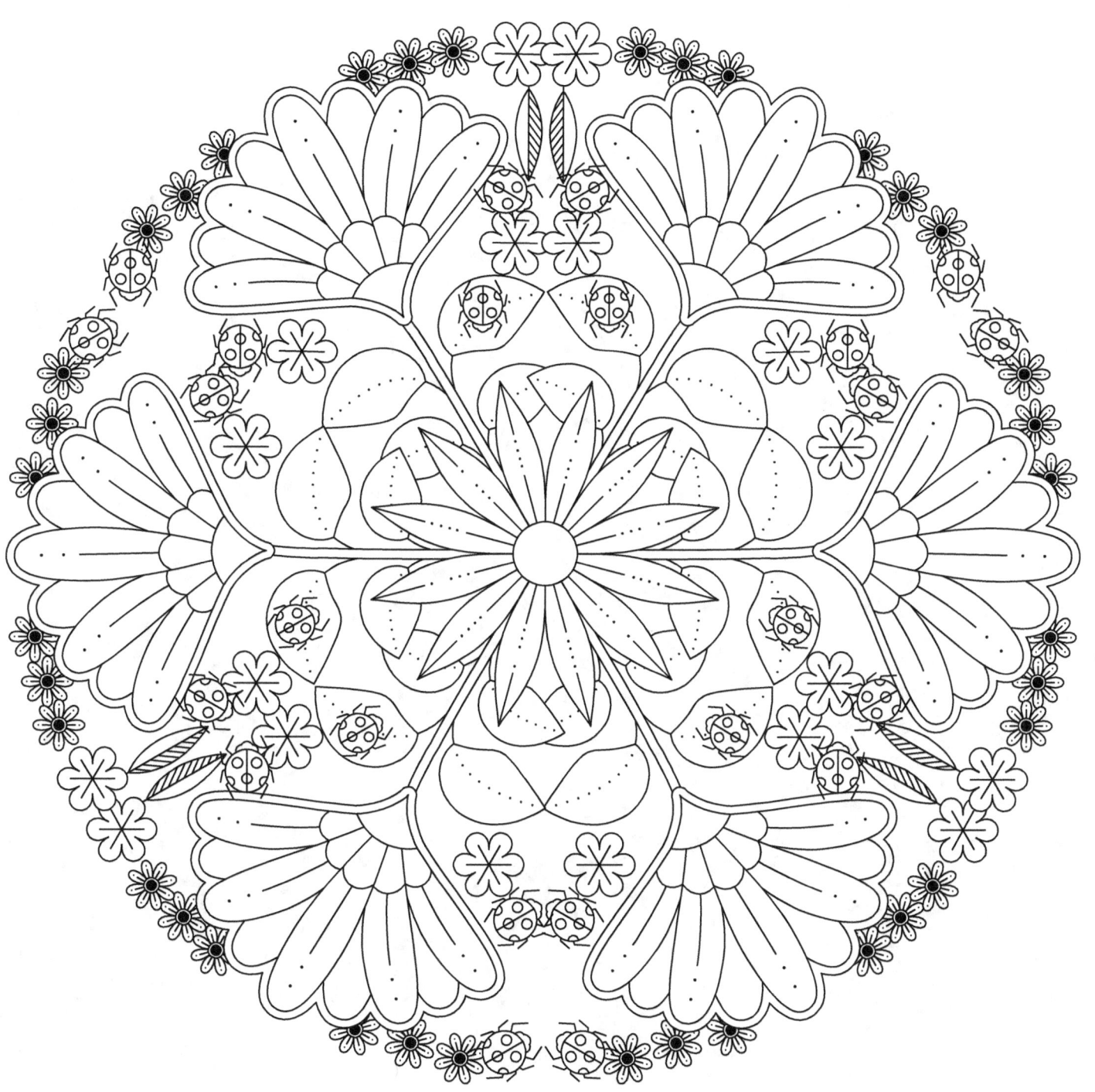

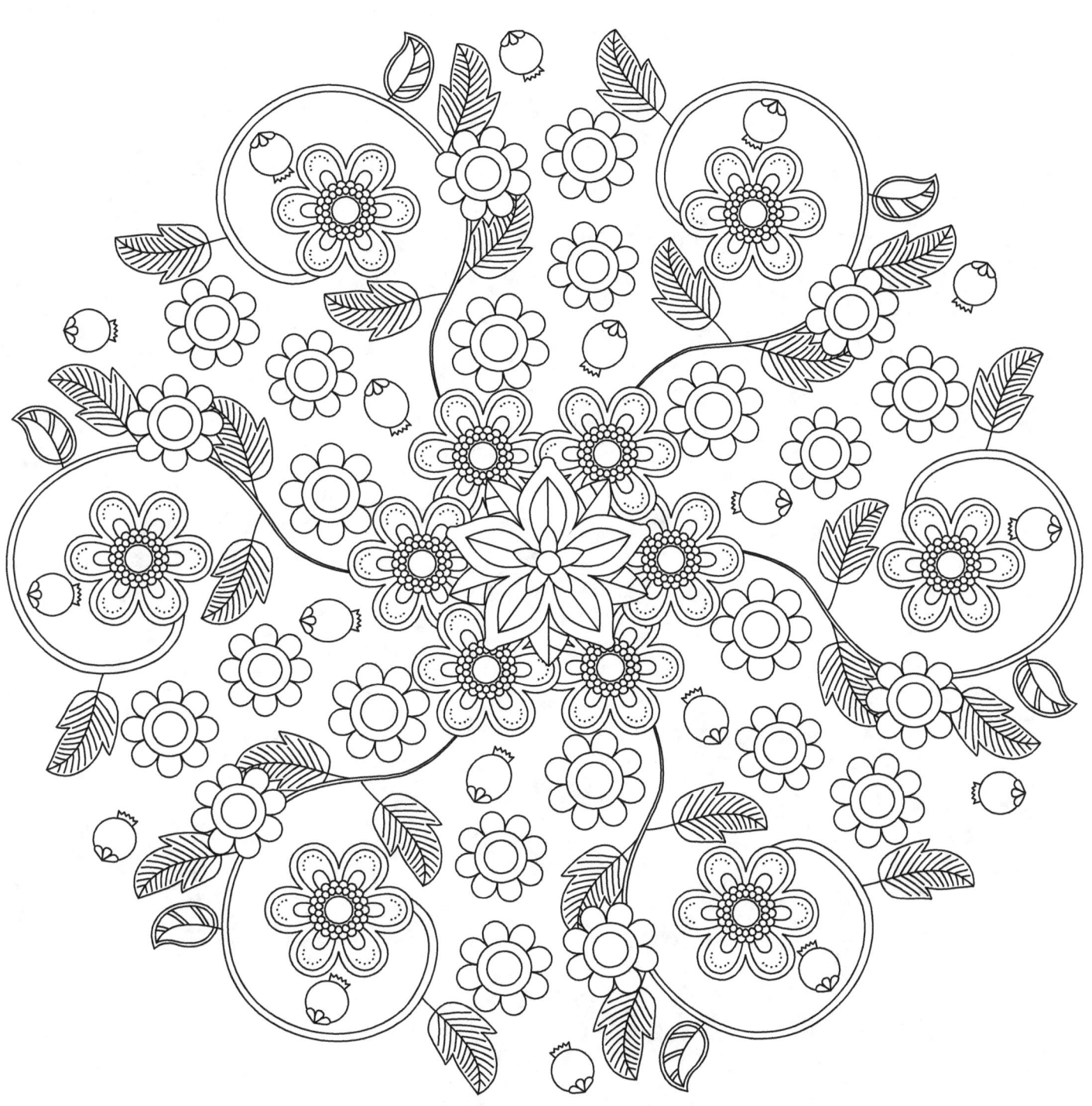

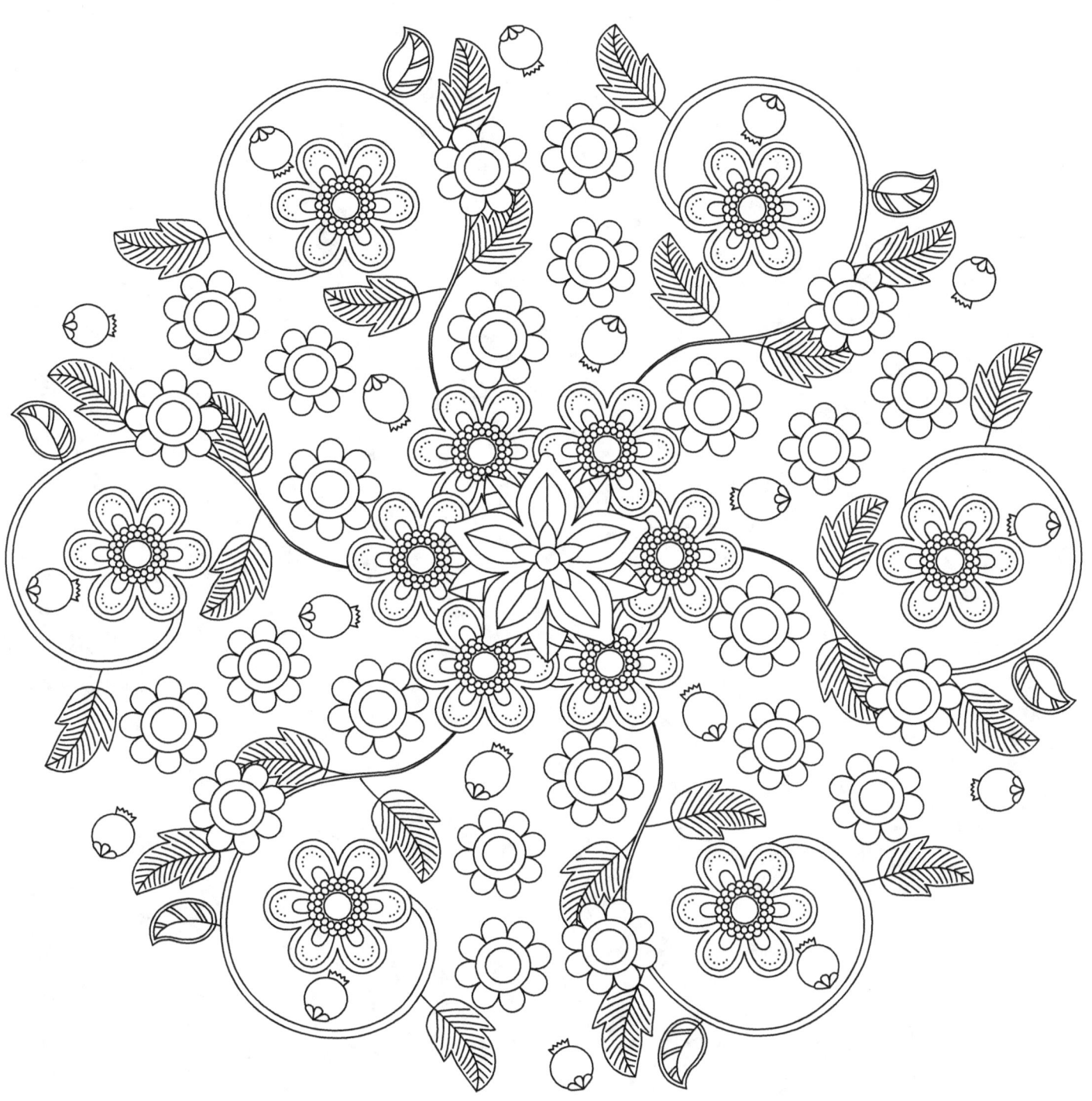

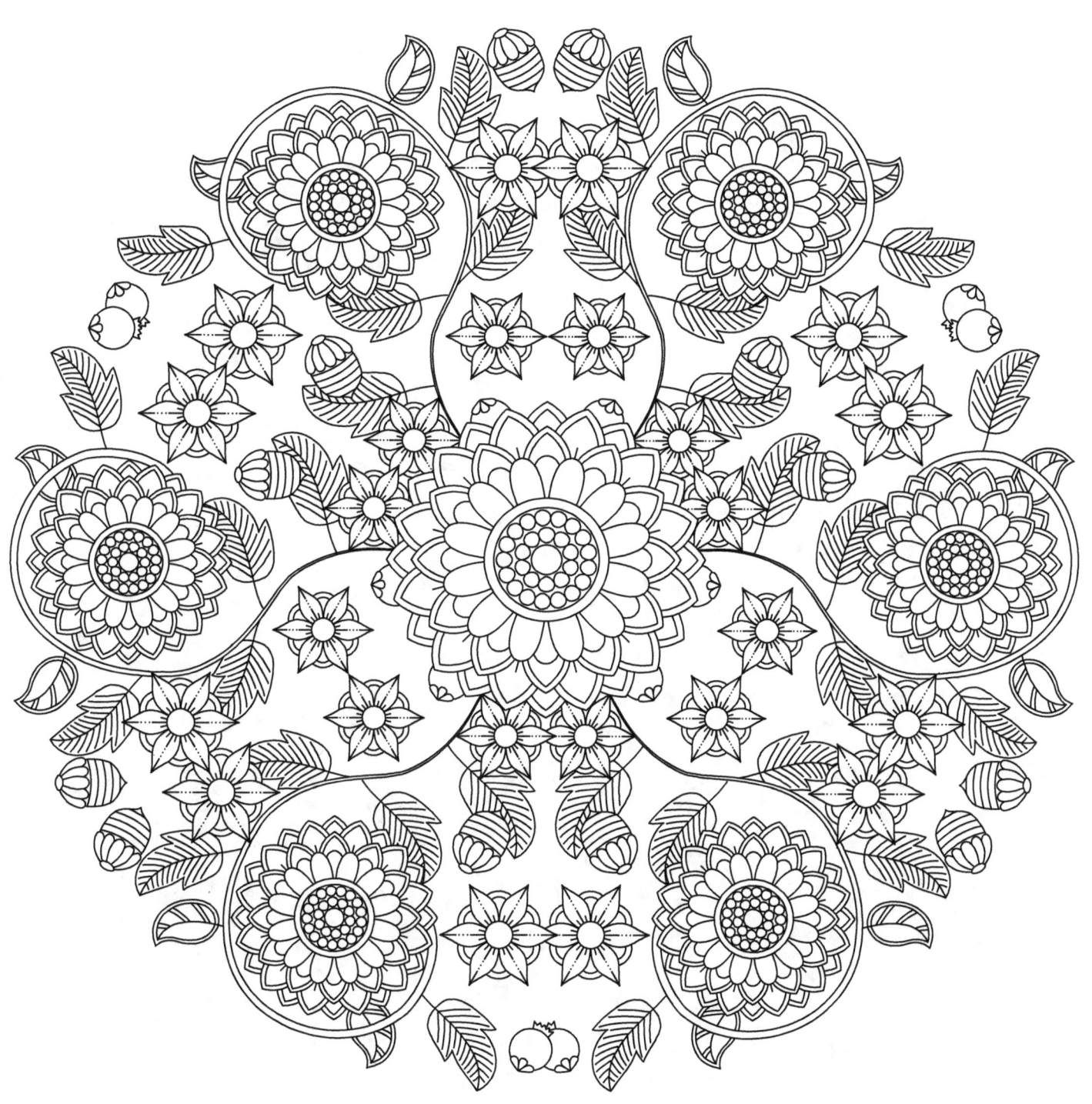

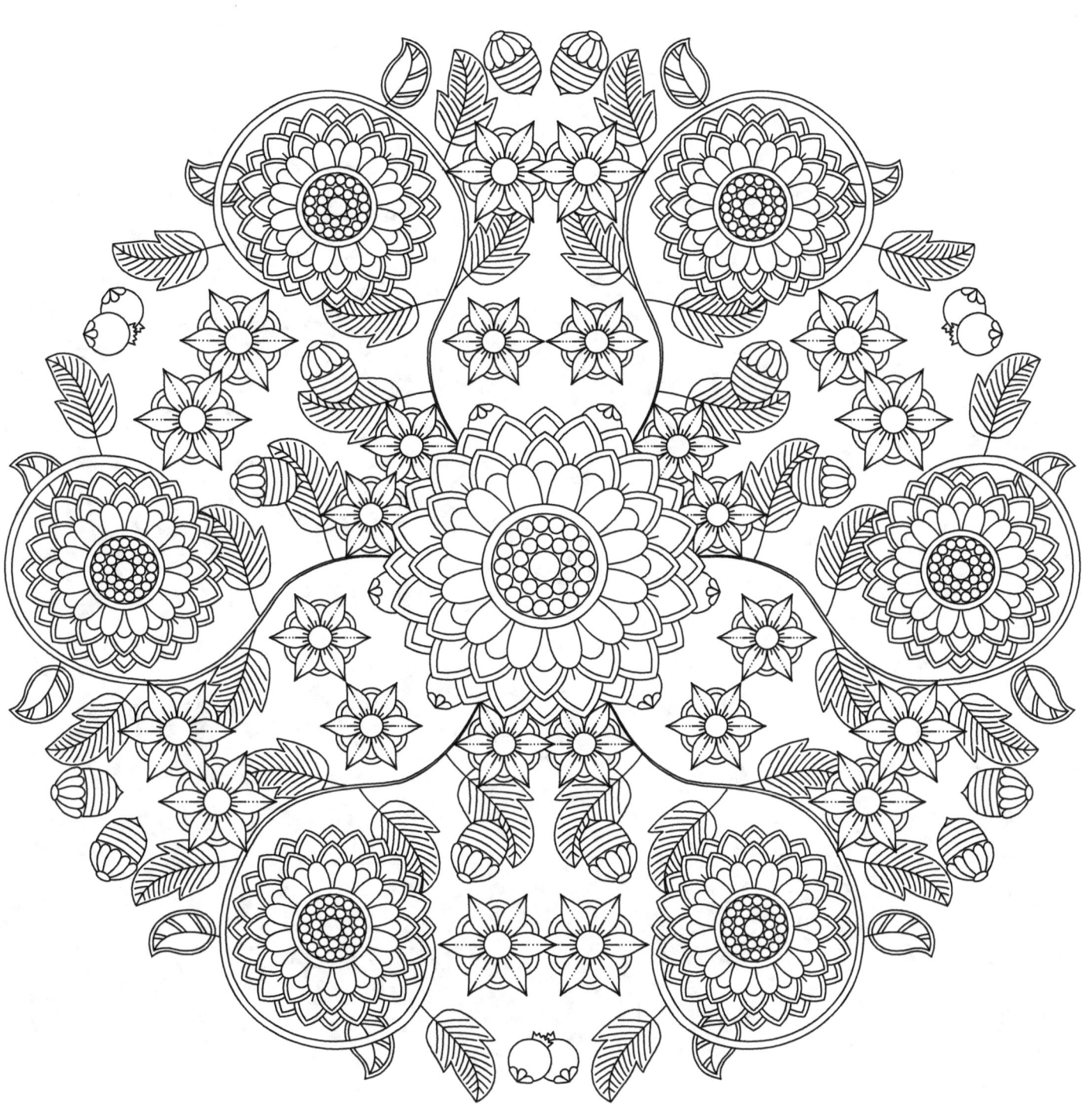

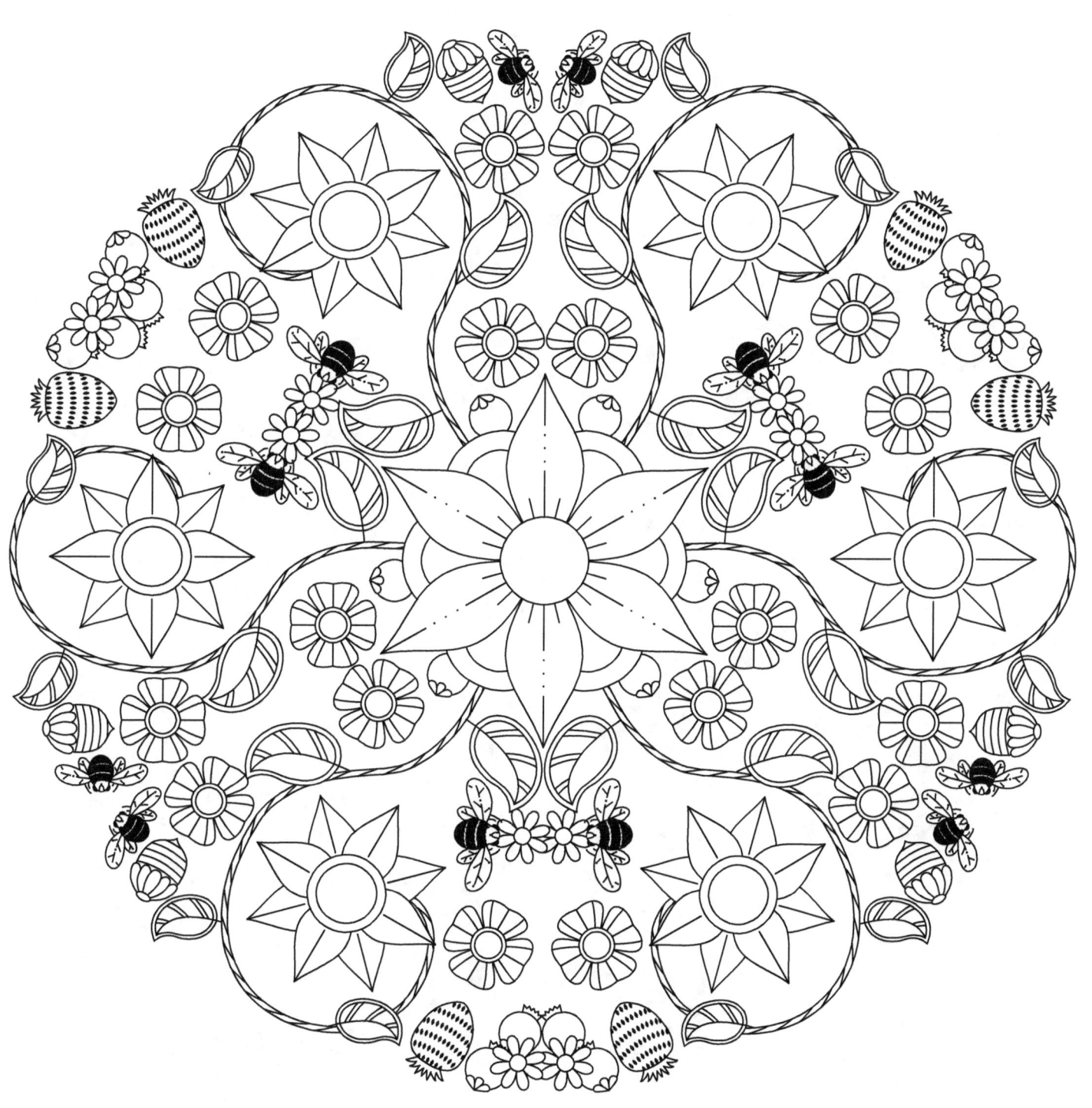

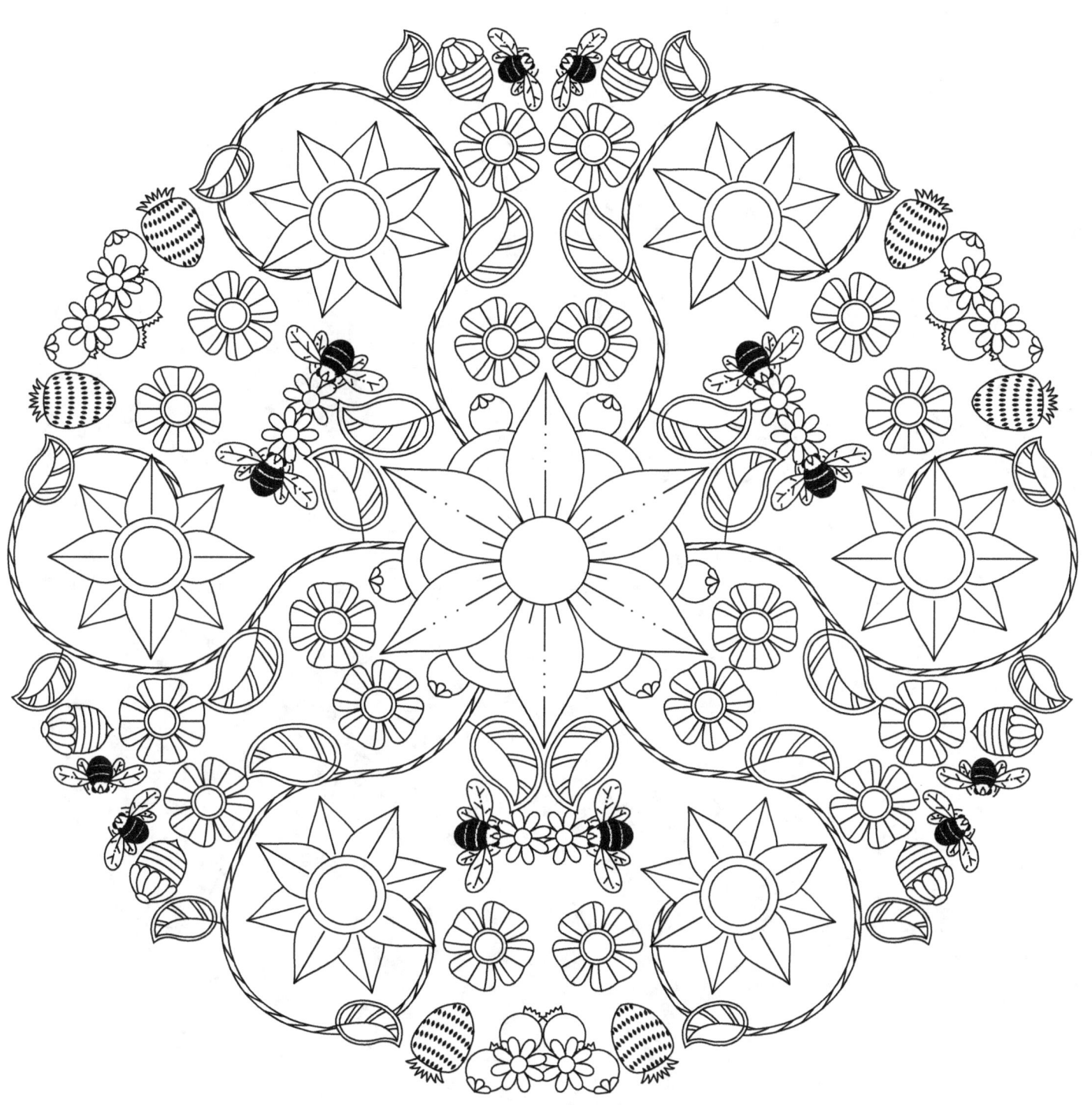

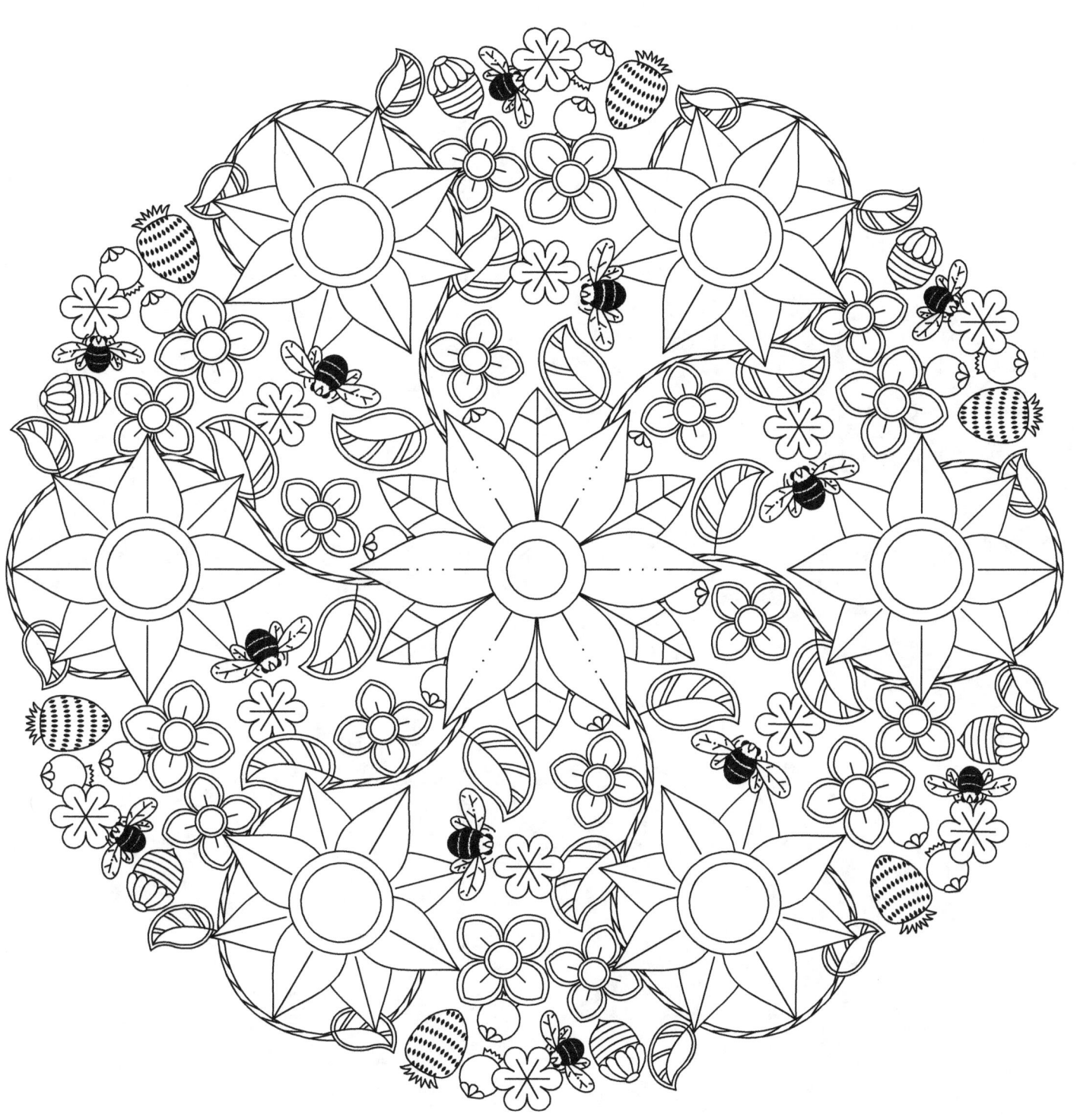

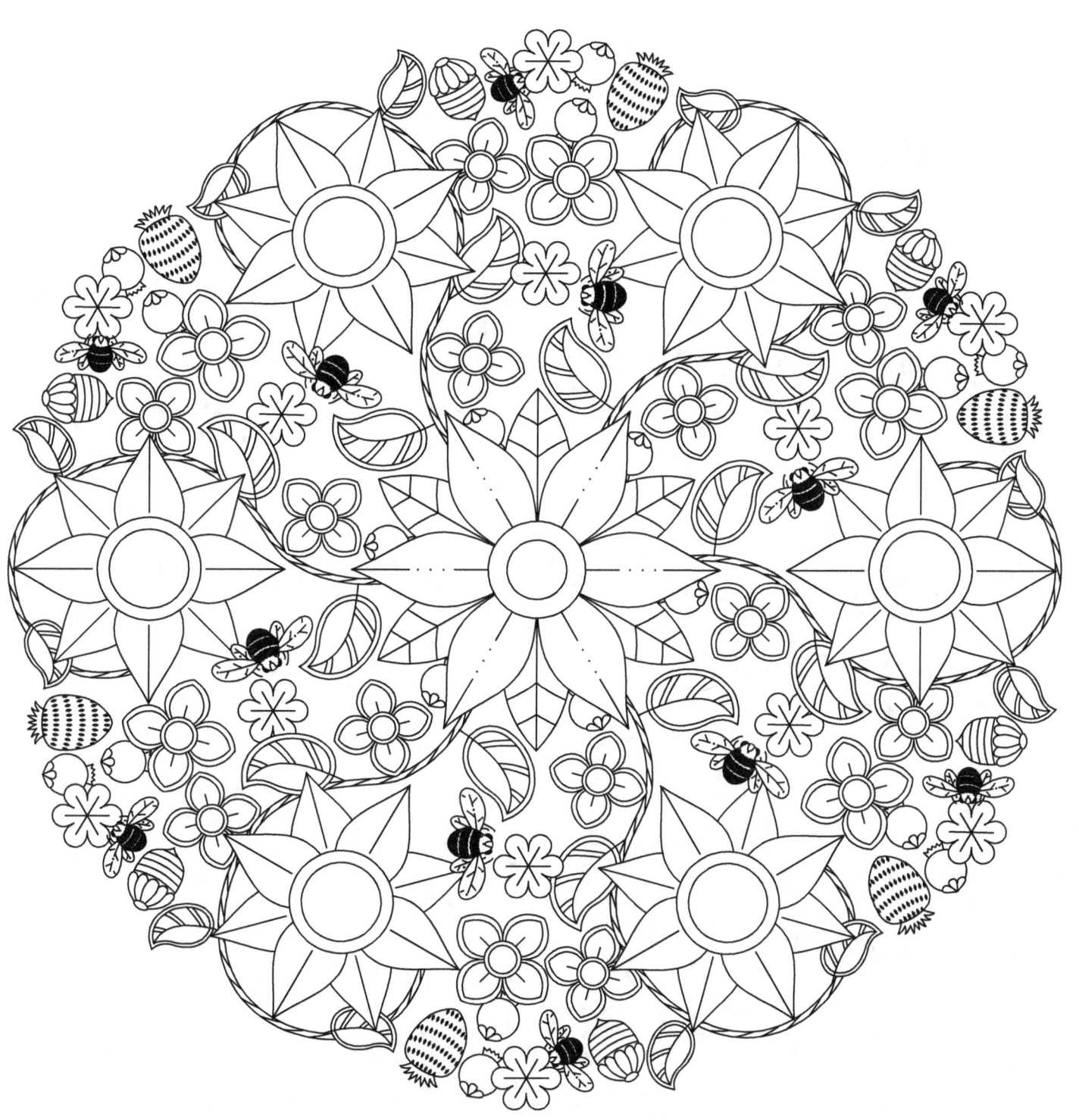

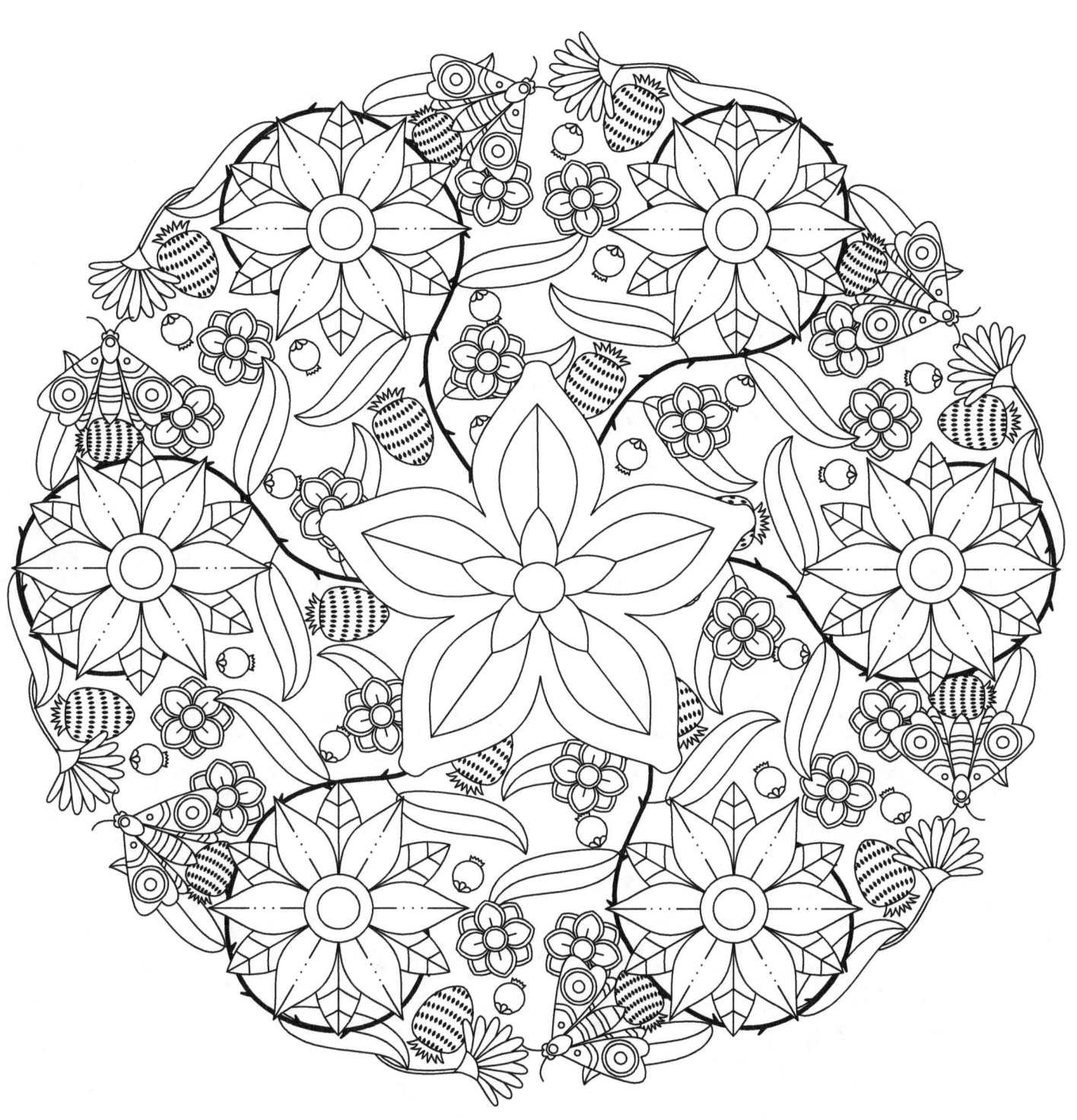

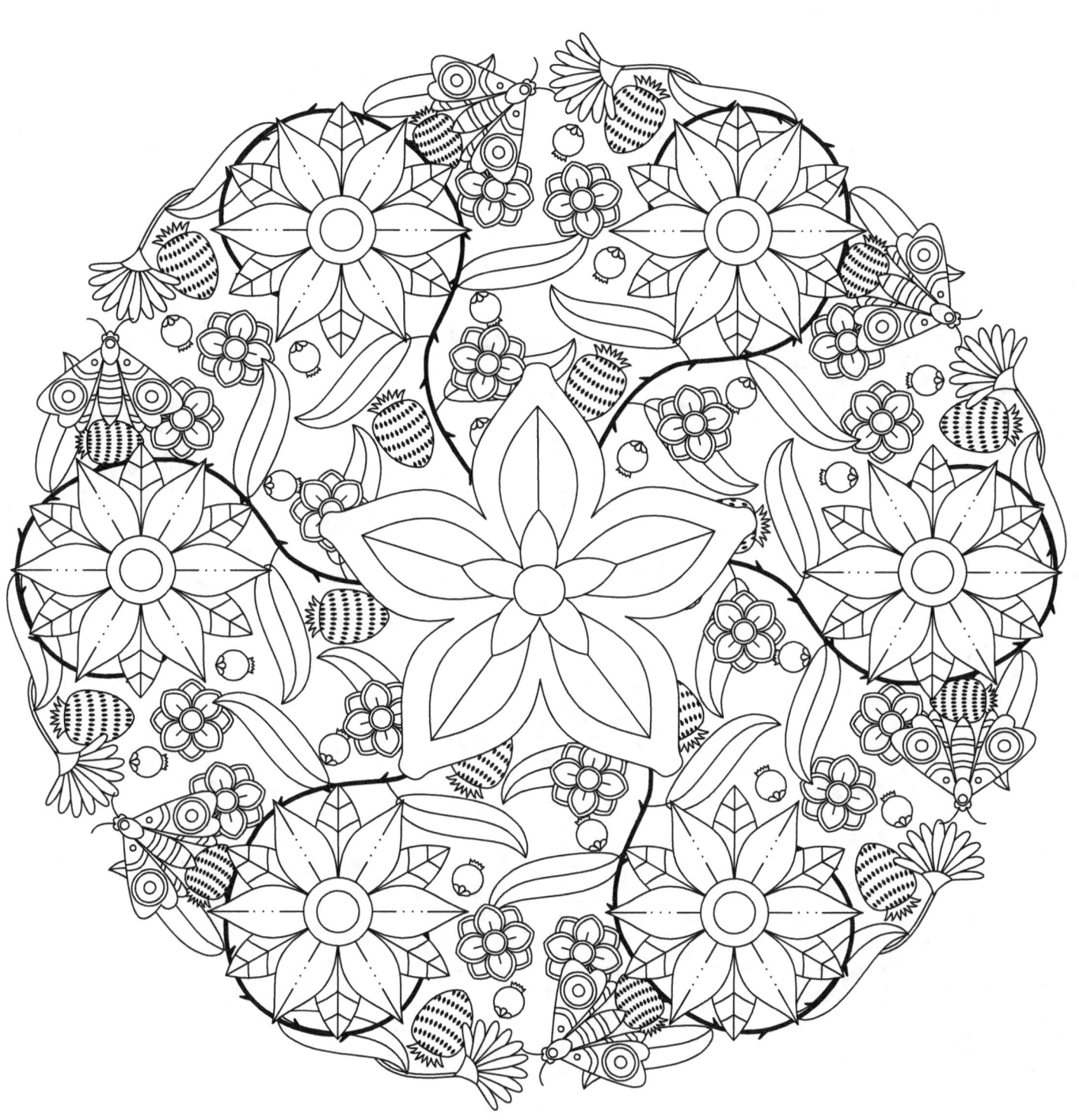

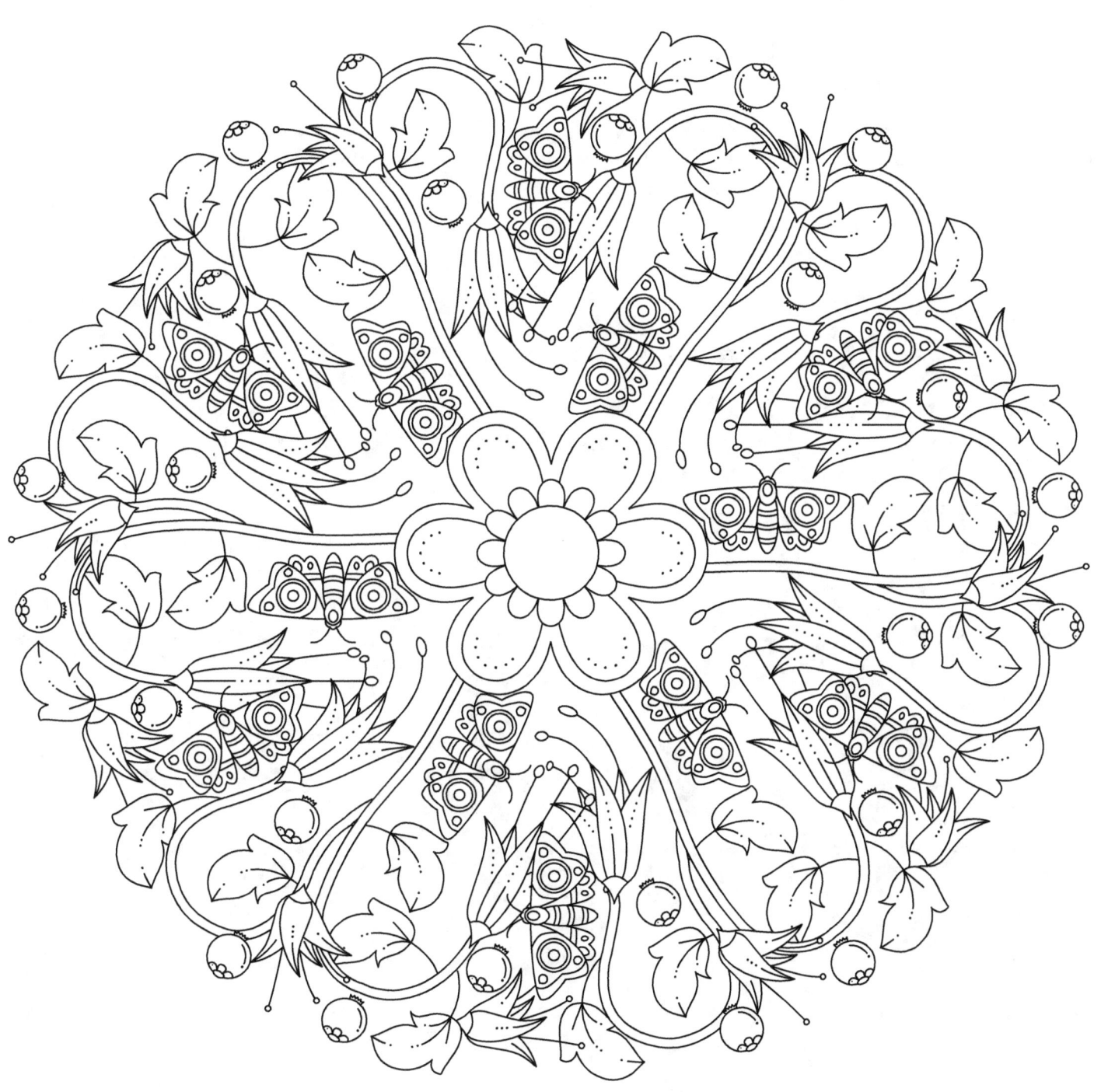

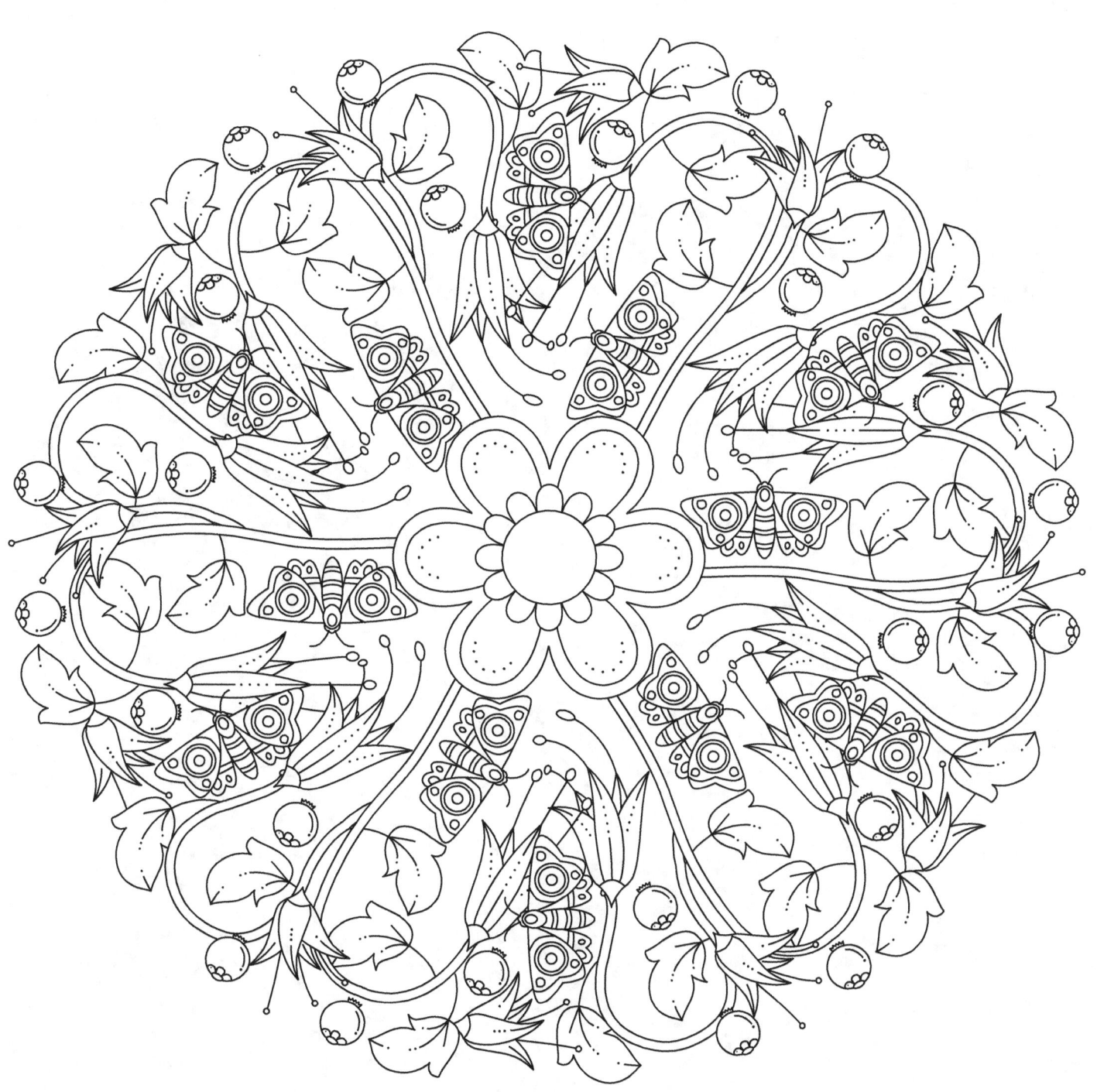

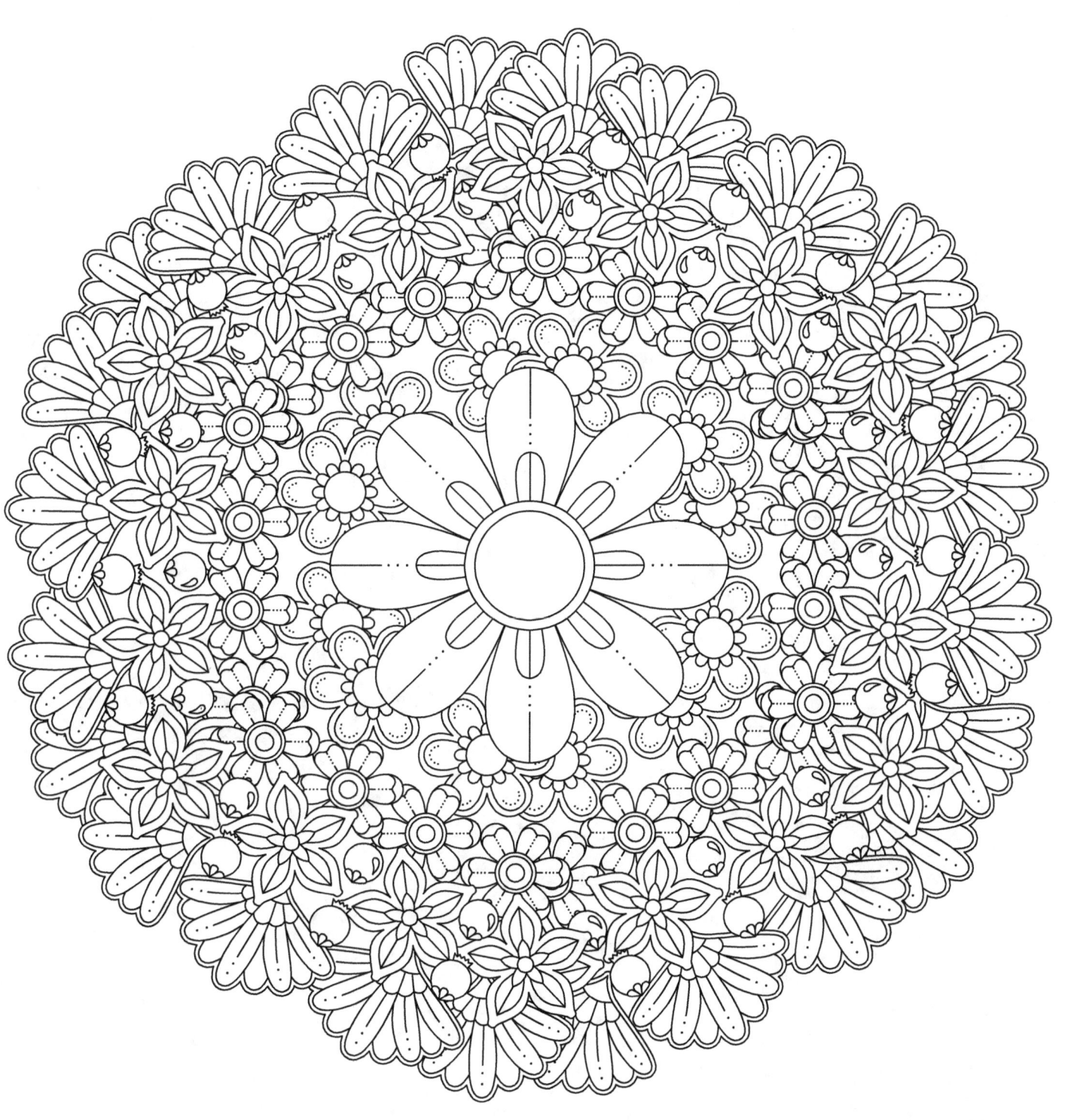

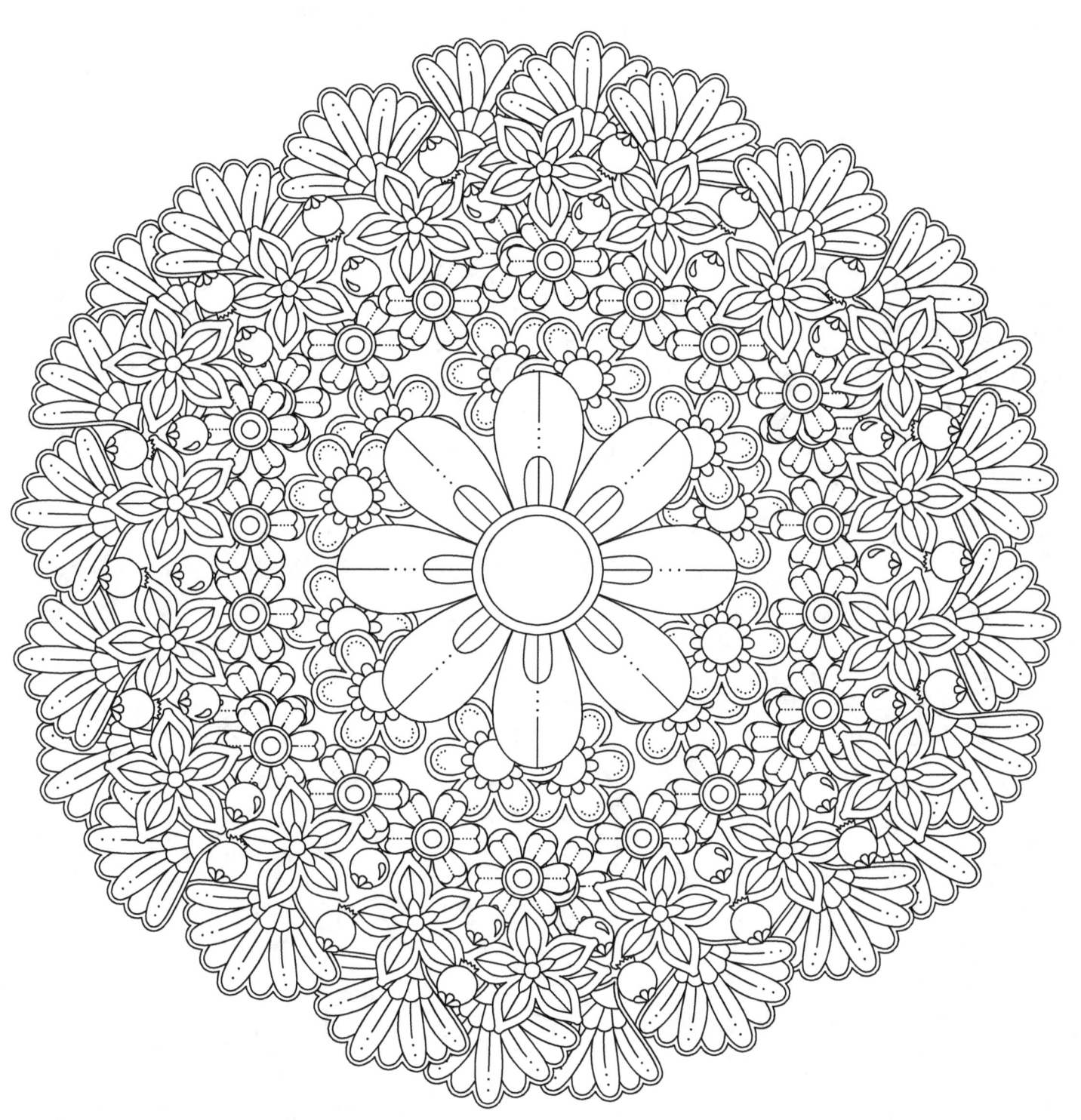

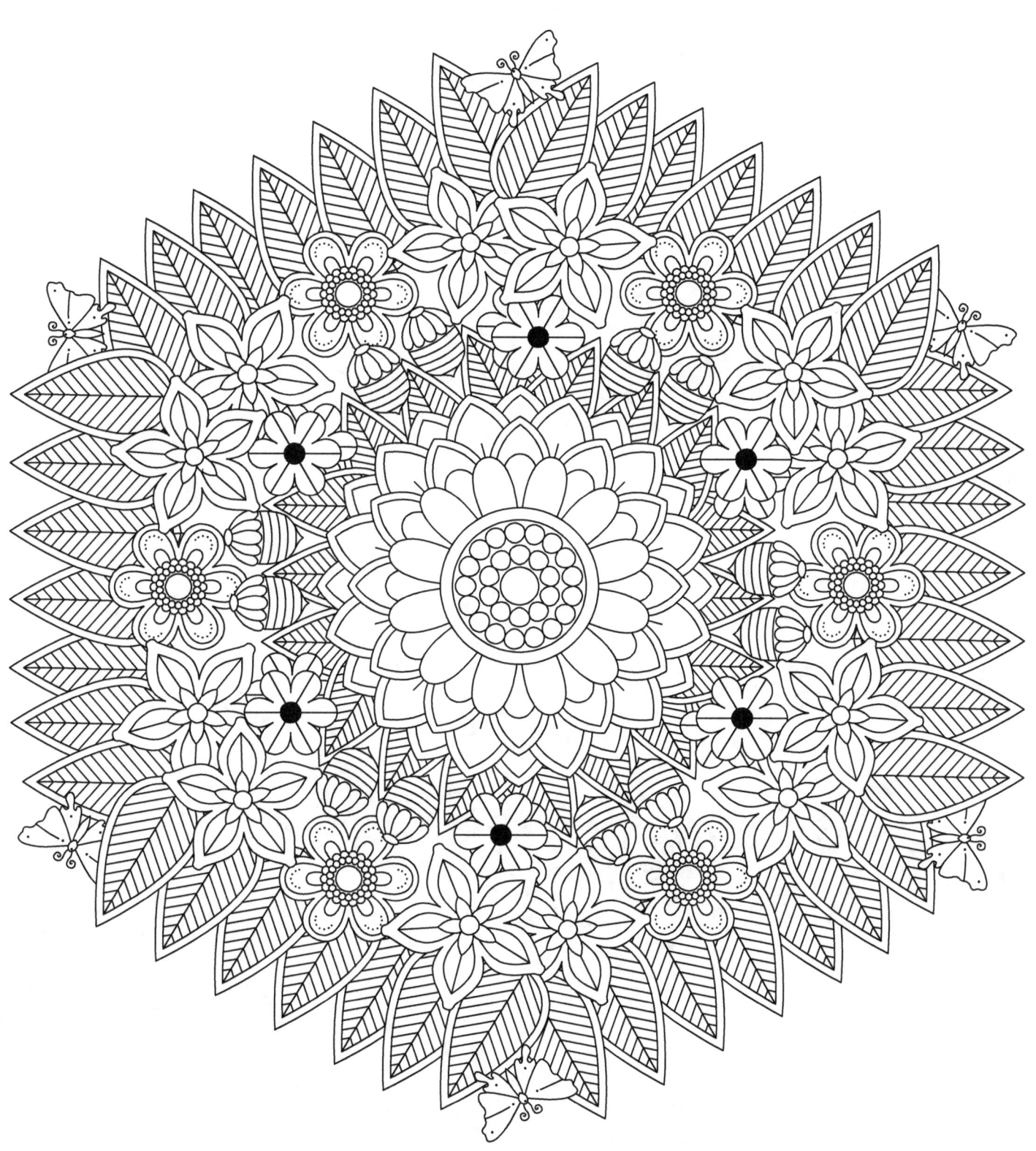

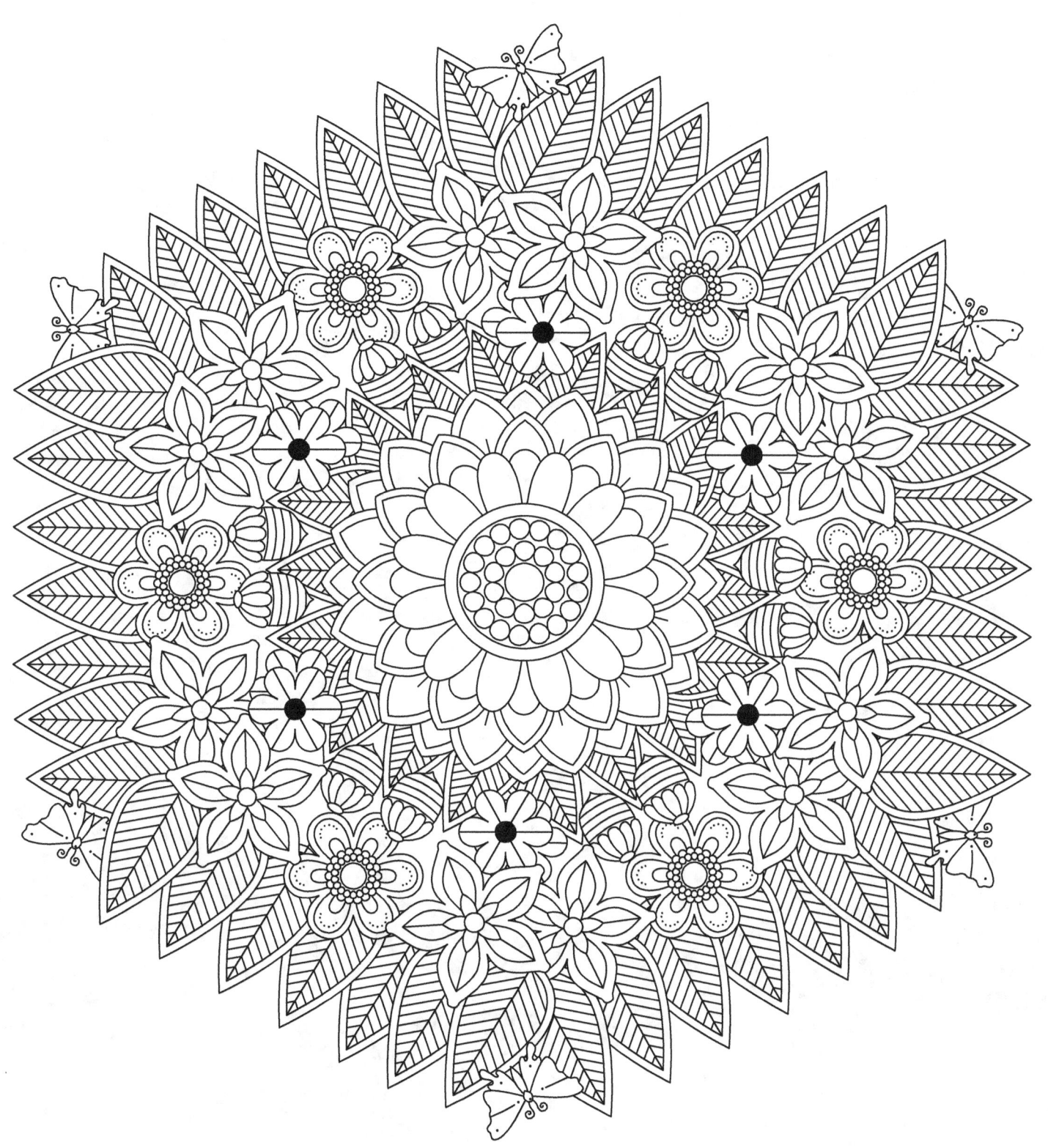

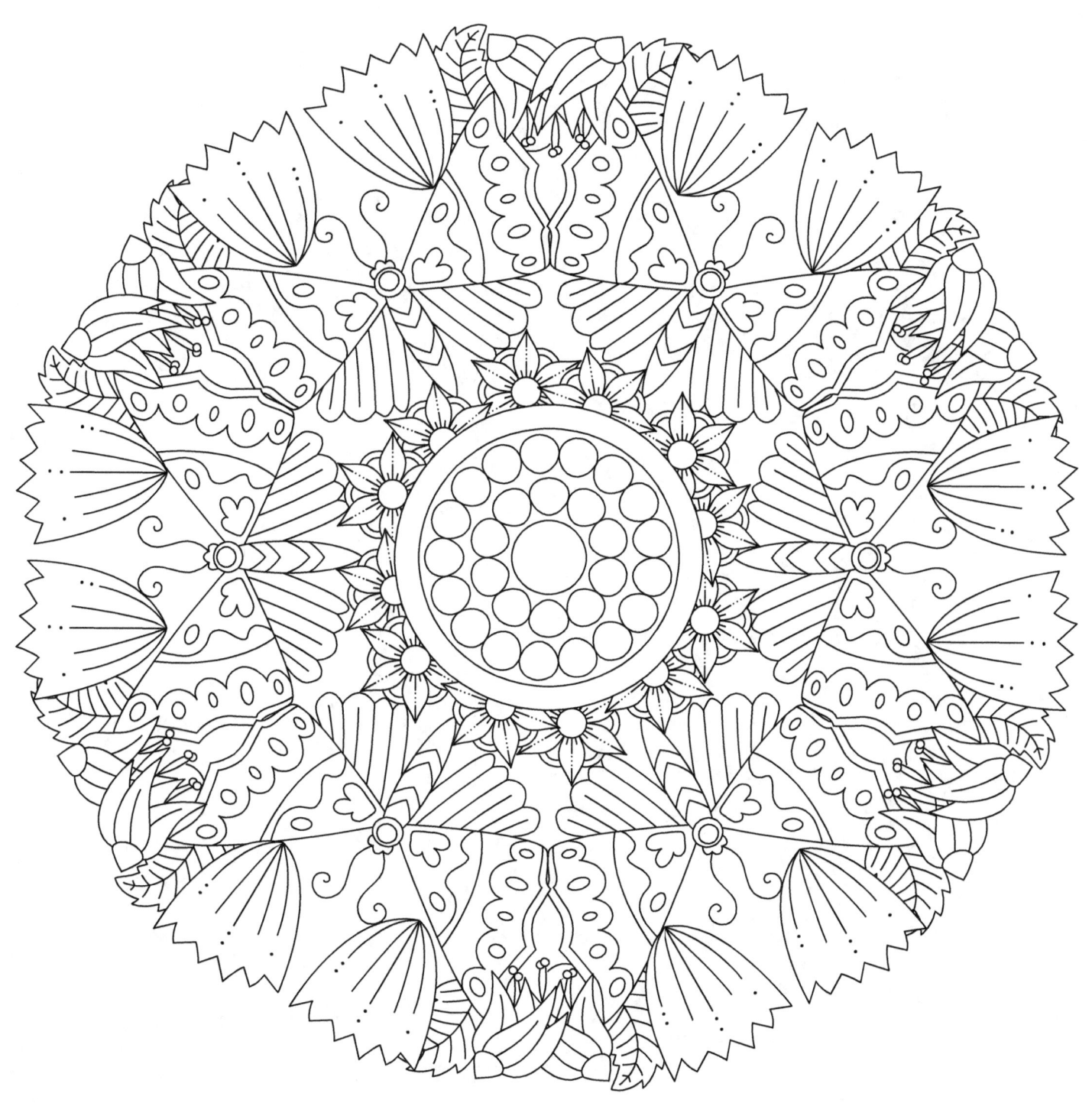

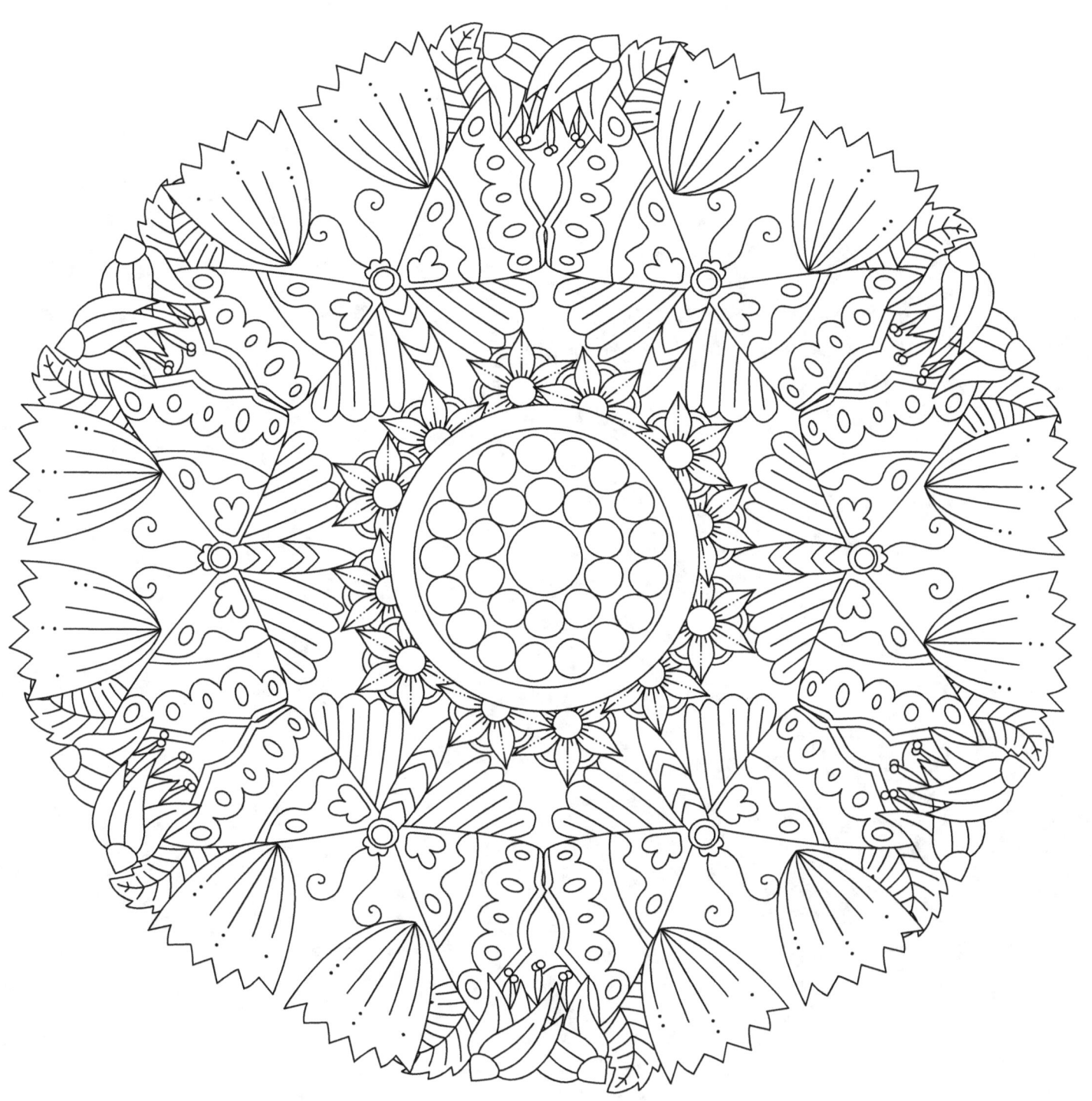

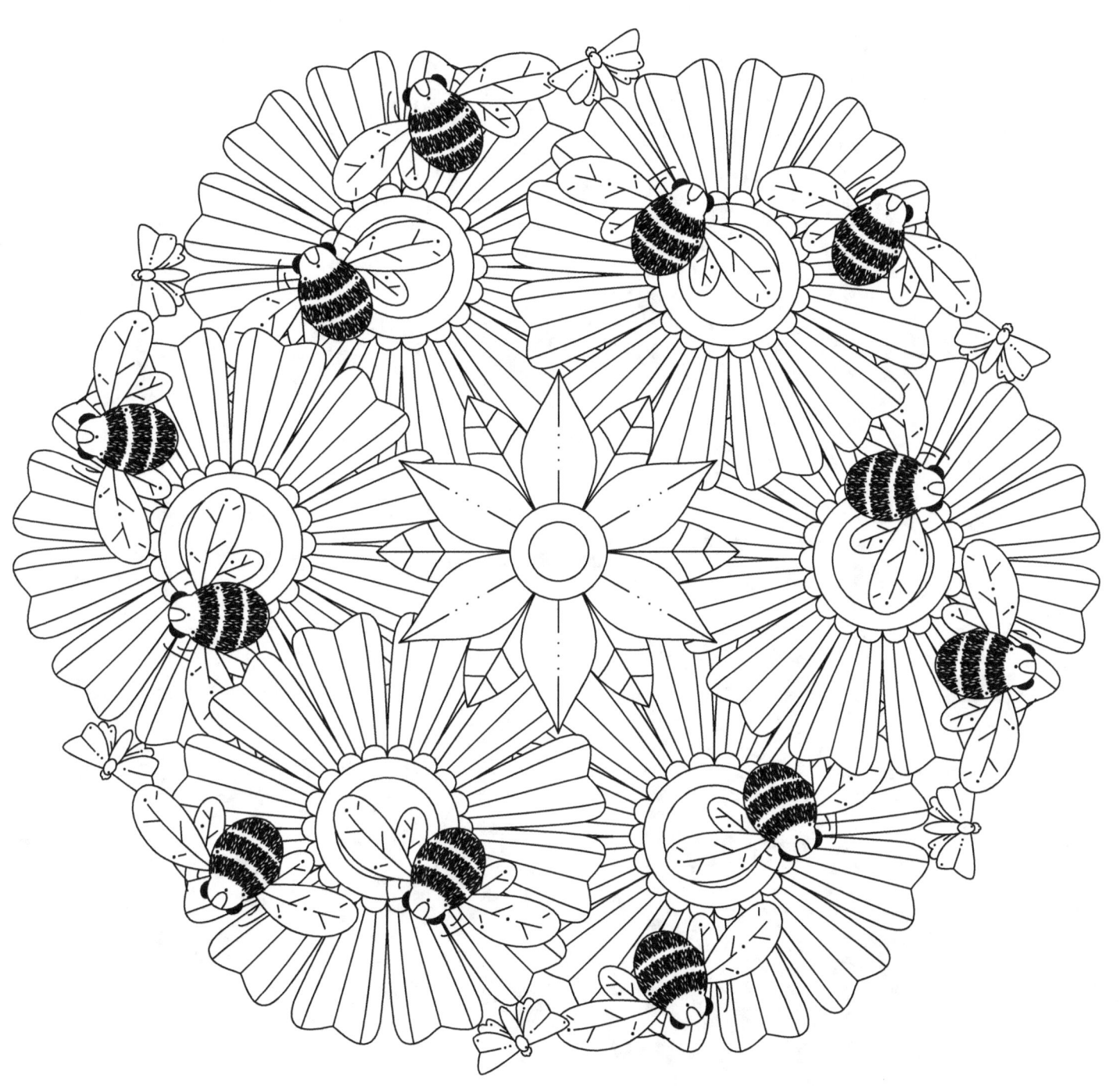

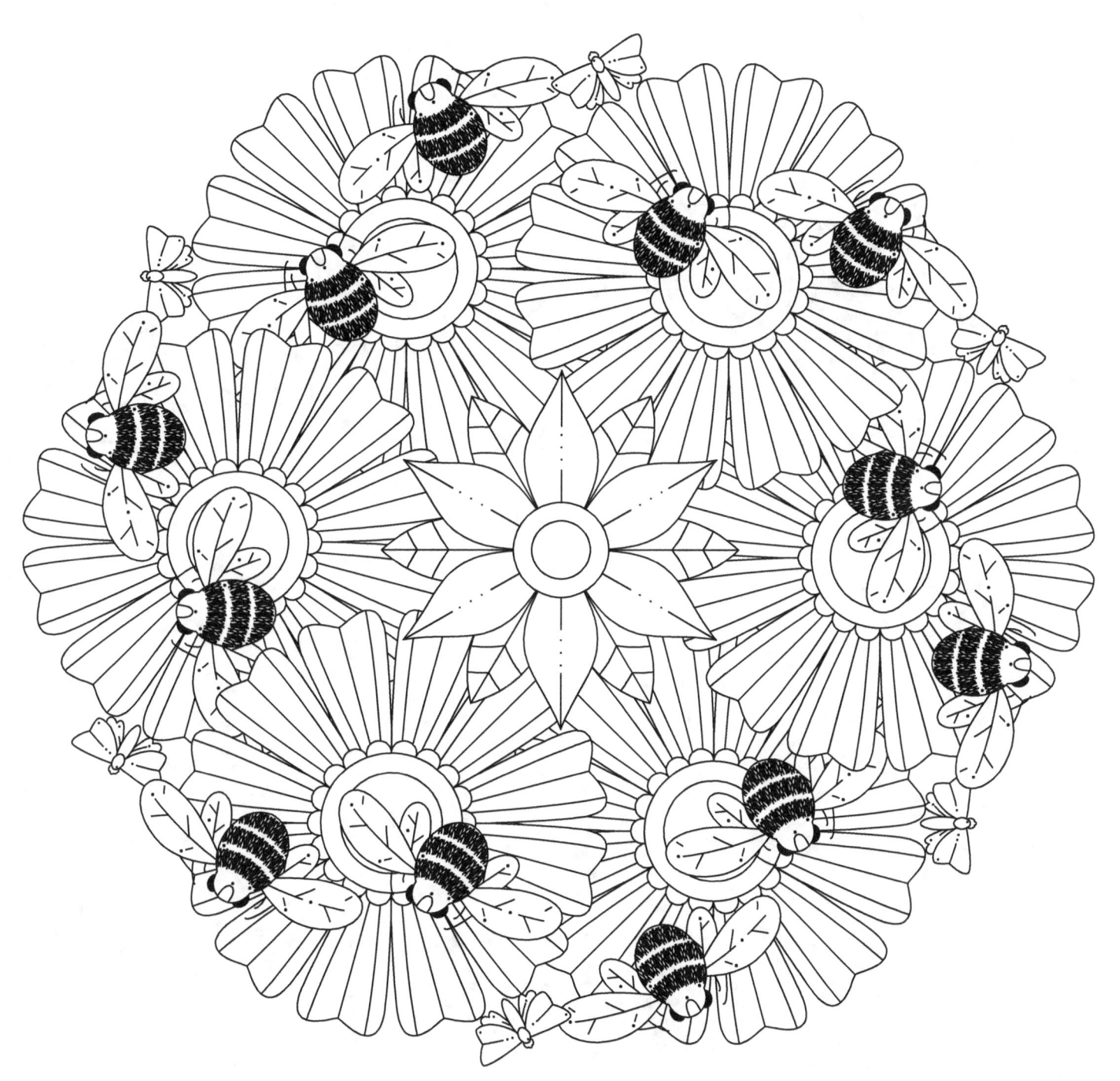

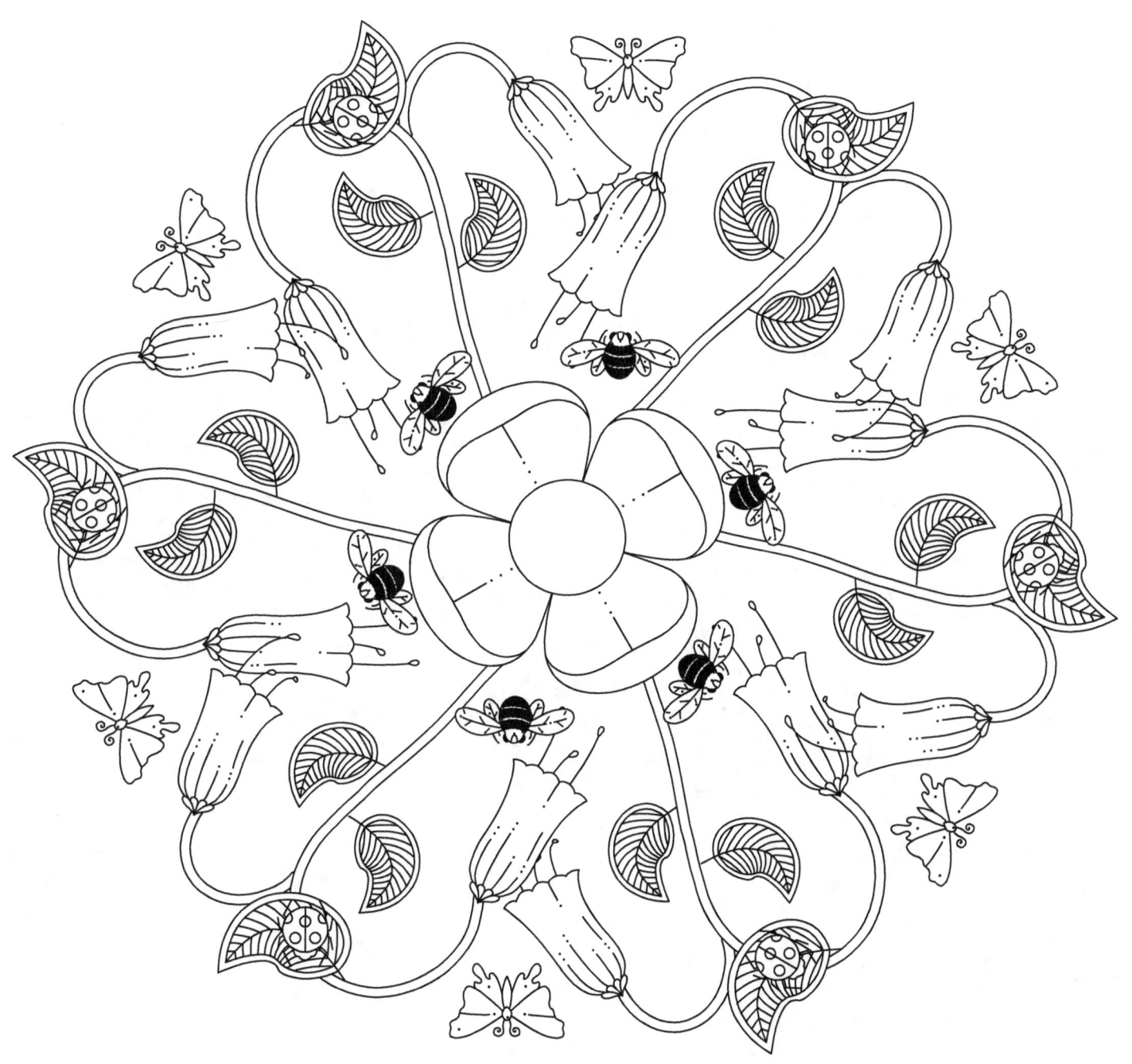

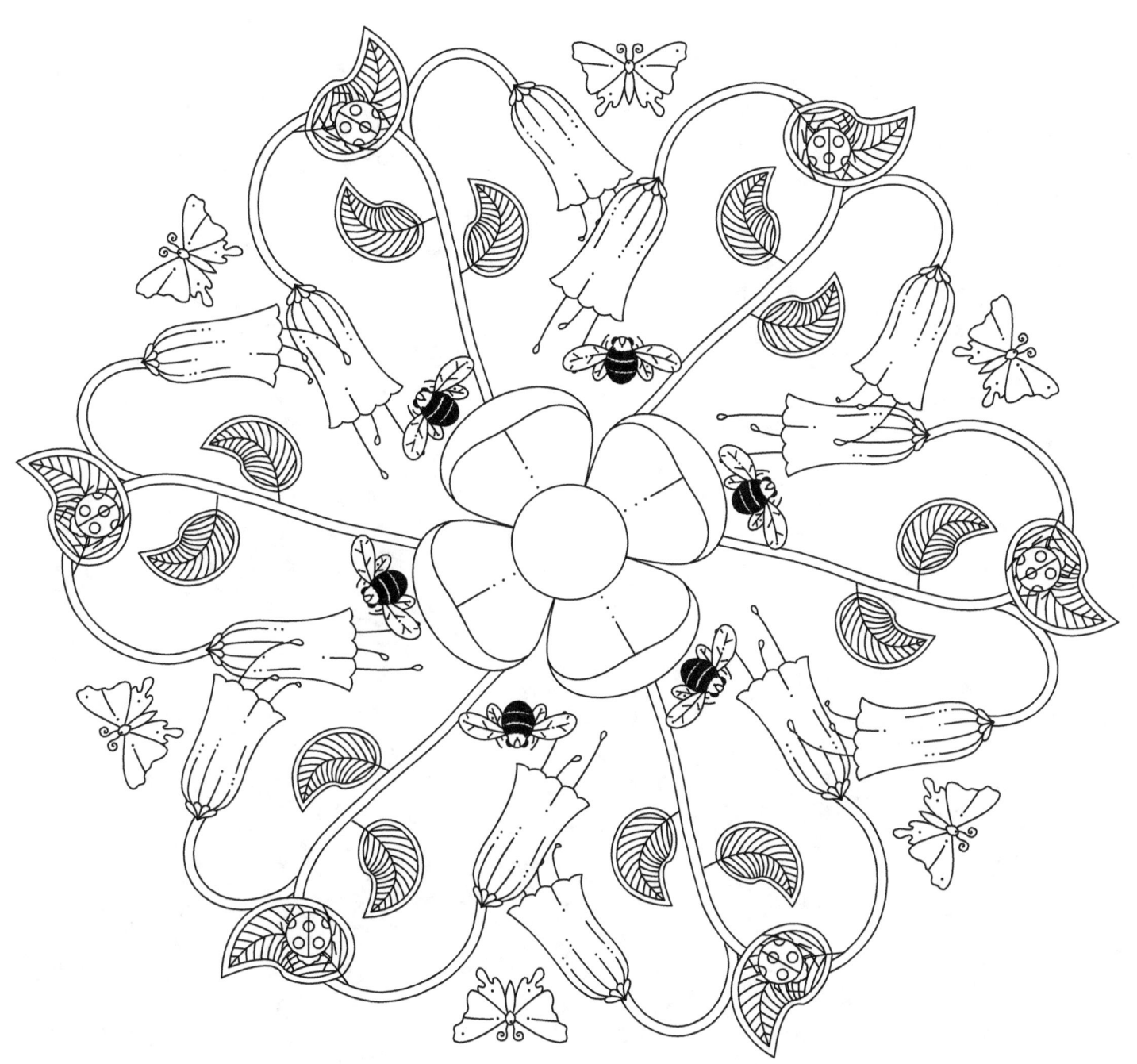

Looking for more coloring fun?

Don't miss these coloring books also in the Stress Relieving Patterns Series!

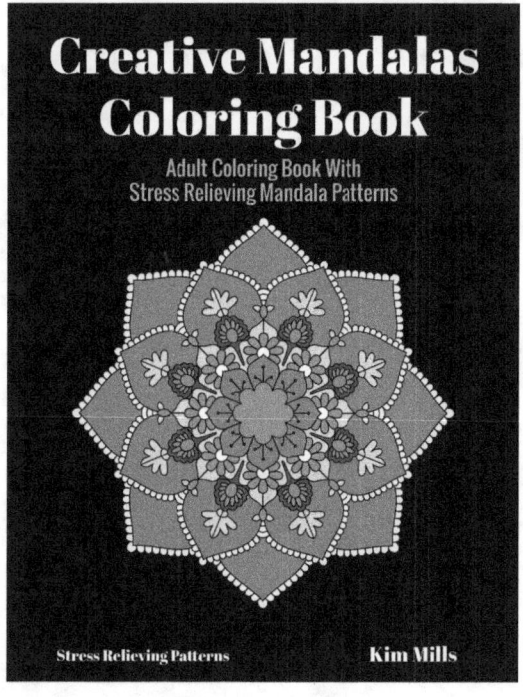
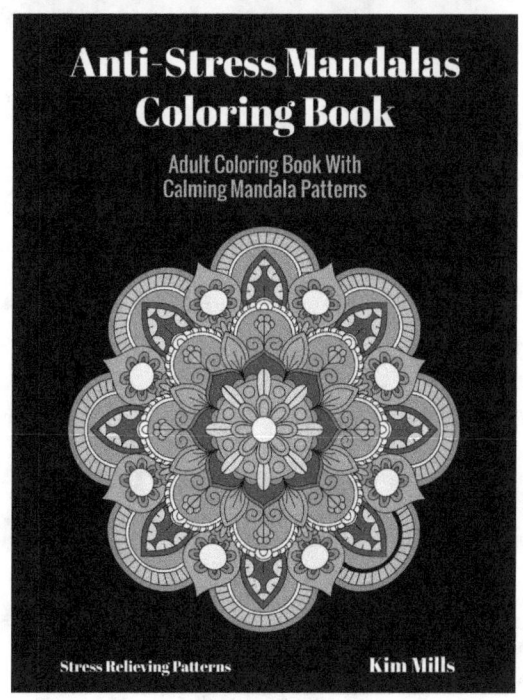

www.ingramcontent.com/pod-product-compliance
Lightning Source LLC
Chambersburg PA
CBHW081207180526
45170CB00006B/2252